How to be a Successful Cartoonist

Randy Glasbergen

NORTH LIGHT BOOKS
Cincinnati, Ohio

This hardcover edition of *How to be a Successful Cartoonist* features a ''self-jacket'' that eliminates the need for a separate dust jacket. It provides sturdy protection for your book while it saves paper, trees and energy.

Other fine North Light Books are available from your local bookstore, art supply store or direct from the publisher.

00 99 98 97 96 5 4 3 2 1

Library of Congress Cataloging-in-Publication Data

Glasbergen, Randy.
 How to be a successful cartoonist / by Randy Glasbergen.
 p. cm.
 Includes index.
 ISBN 0-89134-633-3 (alk. paper)
 1. Cartooning—Vocational guidance. I. Title
NC1320.G59 1995
741.5'023—dc20 95-22856
 CIP

Edited by Diana Martin
Designed by Angela Lennert
Cover illustration by Randy Glasbergen

North Light Books are available for sales promotions, premiums and fund-raising use. Special editions or book excerpts can also be created to specification. For details contact: Special Sales Manager, F&W Publications, 1507 Dana Avenue, Cincinnati, Ohio 45207.

ACKNOWLEDGMENTS

Thank you to everyone who helped out with the questions and answers in this book and to all the great cartoonists who shared their time, knowledge and permissions for this project: Bil Keane, Bill Griffith, Bill Schorr, Bob Thaves, Bob Vojtko, Brian Crane, Bud Grace, Charles Schulz, Chon Day, Chris Browne, Cory Ladd, Dan Parent, Dan Rosandich, Dave Schwartz, Daryll Collins, Frank Cotham, Gerald Dumas, Greg Evans, Jack Ziegler, James Lynch, Jared Lee, Jerry Scott, Joe Kohl, John Caldwell, John Hayes, John Locke, John McPherson, Ken Newton, Kenny Clarke, Leo Stoutsenberger, Linda King, Lynn Johnston, Mark Heath, Marty Bucella, Mort Walker, Pat Bradford, Pat Brady, Pat Sandy, Peter Guren, Rex May, Rick Kirkman, Rick Stromoski, Russell Myers, Ted Goff, Tom Cheney, Tom K. Ryan, Tom Wilson, W.C. Pope, American Greetings, Archie Comics Group, Children's Better Health Institute, Creators Syndicate, Disney Animation, King Features Syndicate, Paramount Cards, The Joe Kubert School of Cartoon and Graphic Art, The Washington Post Writer's Group, Tribune Media Company, United Media, and Universal Press Syndicate.

Also, thanks to my editors: Greg Albert, who helped me launch this project, and Diana Martin, whose suggestions and guidance made a great difference.

About The Author

Randy Glasbergen began his professional cartooning career in 1972 at the age of fifteen. While still in high school, he illustated his first children's book and sold hundreds of cartoons to major publications such as *New Woman*, *The National Enquirer*, *Saturday Review*, *Saturday Evening Post* and *Boy's Life*. After a year of journalism studies, Randy left college to freelance full time.

Today, Randy Glasbergen is one of the most widely and frequently published cartoonists in the United States. His gag cartoons appear regularly in *Going Bonkers*, *Funny Times*, *Woman's World*, *First for Women*, *Good Housekeeping*, *Complete Woman*, *The National Enquirer*, *The Wall Street Journal*, *Campus Life*, and dozens of other publications.

Since 1982, Randy has been the artist and writer for the cartoon panel, *The Better Half*, which is syndicated worldwide by King Features Syndicate and read by millions of people every day. Glasbergen's work as a cartoonist has also brought him a steady flow of humorous illustration assignments for a long list of clients and accounts, including Hallmark Cards, Reader's Digest, White Castle and Ralston Purina. His illustrations have been used for advertising, greeting cards, calendars, books, magazines and educational materials.

Approximately 20,000 Glasbergen cartoons and illustrations have been published in more than twenty-five countries.

In addition to cartooning, Randy has also been a prolific and successful author of greeting card humor. He has served on the humor writing staff at Hallmark Cards in Kansas City and has been a freelance writer for many different card companies, including Paramount Cards, Gibson Greetings, Oatmeal Studios, Paper Moon Graphics, and the Amberley Greeting Card Company. Randy's writing hs been used for cards, mugs, note pads, T-shirts and gift items.

This is Randy's fourth book. His other books are *Ickle McNoo* (Allied Publications), a children's book written by Wendy Danforth; *Getting Started Drawing and Selling Cartoons* (North Light Books); and *Attack of the Teenage Zit Monster* (InterVarsity Press), a collection of cartoons about teenagers.

Randy lives in a small town in rural New York State. He works in a studio located on the third floor of his very old house and is frequently interrupted by his wife, four children, a poodle and five insane cats.

TABLE OF CONTENTS

❶
Getting Started

It's never too soon or too late to develop your natural cartooning talent as a hobby or a career. Find out where to get top-quality training, what the cartooning opportunities are and how much money you can hope to make.

❷
Tools and Techniques of the Pros

What pens, pencils, markers, papers and techniques do the pros use to create their cartoons? This chapter describes a full range so you can use them to draw your own funny cartoons.

❸
Developing Great Style and Characters

Discover how to develop a cartooning style and characters that are successful and saleable for magazines, greeting cards, comic strips and more.

❹
Creating Funny Cartoon Ideas

Learn what's essential to successful cartoon humor. Discover how to be funny with and without words. Overcome obstacles to being funny by discovering how to heighten your sense of humor, fit a funny idea to the right audience, cure writer's block and turn on your creativity.

❺
Turning Your Cartoons Into Cash

Get the advice you need to start being funny for money, right away. Find out where to uncover thousands of buyers for your cartoons, how to market yourself to a variety of markets, the truths about syndication, and what it takes to break into the animation, humorous illustration and caricature markets.

Resources and Extra Stuff

Index

Introduction

If you're curious enough to pick up this book and look through its pages, there's a good chance that you've spent more than a few minutes of your life daydreaming about becoming a successful cartoonist. Perhaps you've looked over the comics in newspapers, magazines or comic books and said to yourself, "I could do that!" Maybe you're someone who likes to create your own outrageous greeting cards instead of buying printed ones from a card shop. Or perhaps you're the funny person in school who's always drawing and doodling endlessly instead of taking notes. If any of these people sound like you, then you are *already* on your way to becoming a successful cartoonist!

The goal of this book is to help you transform your cartooning daydreams into cartooning reality and to answer as many of your cartooning questions as possible. Dozens of the world's greatest and most successful cartoonists, gag writers and humorous illustrators were consulted for this book. Their advice, insights, wisdom and experiences are sprinkled throughout these pages to assist you in reaching your dreams. If you draw cartoons as a hobby, this book will help you discover many new ways to enjoy your drawing time. If you get ex-cited imagining a career in cartooning, this book will help you step beyond your imagination into the exciting and rewarding world of professional cartooning.

You won't find a bunch of drawing lessons in this book. There are plenty of other books that can teach you how to draw funnier noses or feet. The purpose of this book is to help you fine-tune your natural talent and polish it up with the proper tools and creative skills you need to really make your work sparkle! The questions in this book are all based on real questions I've heard from beginners over the years, especially after the publication of my first book, *Getting Started Drawing and Selling Cartoons*. The comments and advice from the great cartoonists featured in these pages came directly from exclusive interviews and correspondence conducted especially for this book.

Whether you draw cartoons for fun or dream of a career in the field, the tips and inside information in this book should help you enjoy cartooning more and become more accomplished and productive. Of course, reading this book is only your first step toward becoming a great cartoonist. The rest is up to *you*!

Getting Started

I've enjoyed drawing cartoons for fun. Everyone says I have talent, but I'm not always satisfied with what I've drawn. What can I do to get really *good* at cartooning?

There are only three basic things you must do to get really good at cartooning: practice, practice and practice! Beyond that, a little training can't hurt. If you want to improve your cartooning, this book is a good place to start. After you read an idea or suggestion in these pages, grab your pencil and give it a try. Don't just read—put the lessons and tips into action. When you're finished reading this book, look for another one to teach you more about cartooning from a different perspective. Every cartooning book teaches something different or unique and you can learn from all of them.

Another way to get better at cartooning is to call a local art museum or college to see if they offer any cartooning classes in your area. It's not unusual for professional cartoonists to teach small cartooning classes.

Successful cartoonists don't all live in big cities, so terrific classes can actually be found all over the world. If you can't find a cartooning class in your area, then enroll in some other type of art class—everything you learn will eventually become valuable to your cartooning.

You might also consider taking a correspondence course in cartooning. One of the best-known courses is called Cartoonerama. Cartoonerama is a 24-lesson course by mail featuring a personal, professional evaluation for each of your assignments. Every facet of cartoon art is covered in this course, including ideas and lettering. Many former Cartoonerama students have gone on to successful careers in comic strips, greeting cards, gag panels, illustration and animation. For more information, write to Cartoonerama, P.O. Box 854, Portland, ME 04104.

You will find that there are many excellent cartooning lesson books in most book stores, full of tips on how to draw cartoon faces, bodies, hands, feet, motion, backgrounds, perspective and more. A good correspondence course will teach you these things—*plus* answer all of your questions and give you specific feedback and personal, detailed, helpful critiques on each lesson and assignment. Best of all, a correspondence course allows you to study at home in your spare time, at your own pace, with plenty of encouragement. If you've got talent, but need a little polishing up, a cartoon course like Cartoonerama could be just what you need.

I'm very serious about cartooning. I'm in high school right now, but plan to make cartooning my career someday. Are there any colleges where I can major in cartooning?

While a number of colleges all over the world offer courses in cartooning and animation, there are no Ivy

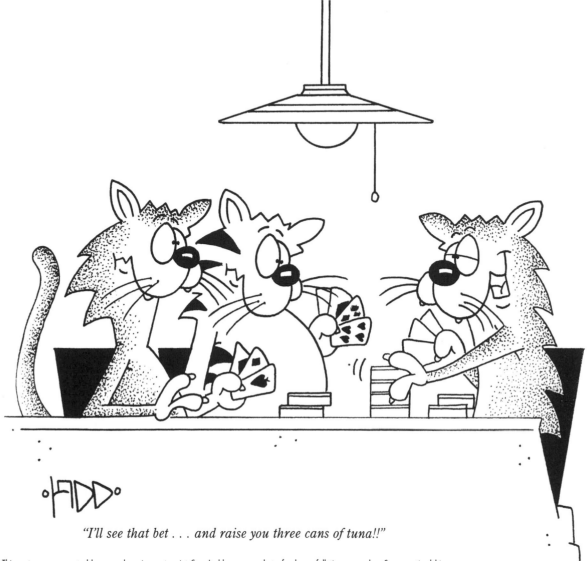

"I'll see that bet . . . and raise you three cans of tuna!!"

This cartoon was created by up-and-coming cartoonist Cory Ladd, who was tragically killed in a car accident as this book was going into production. Although his young career was ended abruptly, Cory Ladd was an outstanding role model for any aspiring cartoonist. Cory was a graphic artist by day and a cartoonist by night. During his day job at the local Pennysaver, he did layouts for advertising circulars and often created cartoons for the Pennysaver and its clients, including special advertising cartoons for large hardware and lumber accounts across the United States. In his free time at home, Cory created comic strips, magazine cartoons and greeting cards, hoping to sell enough to freelance full time someday. Cory practiced his cartooning for several hours each week and made a considerable amount of progress in a relatively short time. He frequently wrote letters to his favorite cartoonists, asking for tips and advice. His enthusiasm and inquisitiveness helped him progress quickly. After making several cartoon sales to *Aquarium Magazine*, *Cat Fancy*, *First for Women*, *Saturday Evening Post*, *Bird Talk* and other publications, Cory's work had improved to the point where newspaper syndicates and greeting card companies were becoming more and more interested in his work.

League cartooning universities . . . yet! The closest thing is the Joe Kubert School of Cartoon and Graphic Art in Dover, New Jersey. This highly recommended school is a three-year program offering a complete course in cinematic animation and cartoon graphics. *This is not a correspondence course!* This school is very well respected by top professionals and is accredited by the National Association of Trade and Technical Schools. Graduates have found employment in comic books, syndication, greeting cards and animation with top companies, including Disney Studios, Hallmark Cards, and Marvel Comics. The faculty is made up of experienced professionals whose credentials include *Prince Valiant, Superman, Bugs Bunny, Tiny Toons, Doug, Wonder Woman, Batman, Swamp Thing, Archie*, and *X-Men*. Scholarships and financial aid are available for qualifying students. For additional information, write to the Joe Kubert School of Cartoon and Graphic Art Inc., 37 Myrtle Ave, Dover, NJ 07801, or call (201) 361-1327.

If you'd like to gather more information on college-level cartooning and animation courses, consult college catalogs, talk to your school counselors, and send a few letters of inquiry to the schools you are interested in. Many of the cartoonists whose work appears in this book improved their cartooning skills while attending art school; many others have no formal training whatsoever. A solid art education is not mandatory for all forms of cartooning, but it is always an asset, particularly if you are planning to seek employment in skilled careers such as greeting cards, animation or advertising.

With all the great talent out there, how can I ever break into the cartooning business? What chance do I have of competing against the professionals❓

You have the same chance that Jim Davis had when he drew the very first pencil sketch of Garfield. You have the same chance that Daryll Collins had before he drew his first funny greeting card character. You have the same chance that Matt Groening had when he was called to create *The Simpsons* for television. None of these famous cartoonists was born clutching a one-way ticket to success. They all had to confront and overcome many of the same obstacles that are currently standing between you and your dreams.

While all great cartoonists are born with some degree of talent, talent alone is not what makes you great. Hard work, practice, intelligence, drive, passion, originality and persistence are what transform talent into greatness. Taking time to work on your cartoons instead of zoning out in front of the television all weekend—that's how you become a great cartoonist. Drawing, tearing up your drawings, and starting over again and again—that's how you become a great cartoonist. Continuing toward your goals, learning lessons from your mistakes and failures, constantly improving and never giving up until you succeed—that's how you become a great cartoonist.

Don't let the fear of competition stop you from going after your dream. There has been competition ever since cartoons were first published regularly a hundred years ago.

Dan Parent, who drew this cover for Archie Comics, is a graduate of the Joe Kubert School of Cartoon and Graphic Art and, like most professionals, speaks very highly of the school. "My teachers were industry professionals that I'd admired for a long time. The work load was unbelievable, but I feel it really prepares you to meet deadlines and improves your art ability much faster than doing it at home on your own undisciplined terms. The other good thing was that even though it's a comic book school, we were well-trained in other areas like human figure, advertising, and methods and materials."

(Long before that, Neanderthals competed for drawing space on cave walls!) Over the years, thousands of people just like you have found some degree of success in cartooning, despite the competition. When Bill Watterson first created *Calvin and Hobbes*, the newspaper pages were already stuffed with plenty of great comics and, frankly, nobody really needed another new comic strip. Despite that, Watterson made his creation one of the most popular and successful comics of all time.

Granted, not all cartoonists will reach the same degree of success as Charles Schulz, Walt Disney, Chuck Jones or Gary Larson. Likewise, all basketball players won't achieve the same greatness as Larry Bird or Magic Johnson, and every kid who takes piano lessons won't become Elton John or Billy Joel. But every cartoonist who works hard and cares about his work can improve and grow and make progress. Regardless of your natural talent, you do have a great deal of control over your own progress and potential. Nothing of value comes easy, though, and success in any field demands countless hours of hard work, dedication and sacrifice.

I enjoy drawing cartoons and doodling for fun, but I have no desire to do this sort of thing for a living. Is there any way I can make good use of my talent without making a career of it?

Nearly everyone loves to look at cartoons and funny drawings. Once your friends and family realize you have a talent for cartooning, there will probably be plenty of opportunities for you to use your art in a number of different ways. Your church might appreciate some cartoons for their newsletter, or your school might welcome your cartoons for their newspaper. You could draw funny pictures or caricatures for children's birthday parties, design greeting cards or party invitations for friends, or do posters for local clubs and organizations. You might just want to continue drawing and doodling for fun while you listen to TV at night— holding a pencil is healthier than holding a potato chip!

I'm pretty good at cartooning, but my life is so busy it's hard to find time to draw. Just the same, I'd like to start making some extra money with my cartoons. I think I need help getting organized. Any suggestions?

If you want to organize your life to find more time for your cartooning, try setting some powerful goals for yourself. Establish some cartooning goals that are exciting and energizing, goals that you can't wait to achieve. If you are excited about achieving your goals, you'll find it much easier to get organized and allocate the time needed for your cartoons.

To create a list of specific goals, ask yourself the following questions:

- Why should I make time for cartooning? What do I want to get from it?
- How many hours a week do I want to devote to cartooning?
- What kind of life will I have if I succeed at cartooning?

What makes a great cartoonist? According to *Peanuts* creator Charles M. Schulz, the secret is "complete originality." Schulz advises, "Definitely go to a good art school, but make sure you get some training in the practical aspects such as lettering. It is probably very important to try to keep up with everything that goes on around you. Also, read a lot." Schulz admits that "fanaticism and a high degree of competitiveness" also played a large role in getting him to the top of his profession.

Cartoonist Profile:
JOHN McPHERSON

John McPherson has one of the wildest comic art styles in the business. His outrageous art is a perfect match to his outrageous ideas. John believes that the best cartoon is "an idea that is so bizarre that no one else could have possibly thought of it. On the other hand, if no one can relate to the idea, it's lost. A great cartoon should be wild, but also based on some degree of truth."

Before finding success as a cartoonist, John was employed as an engineer. After leaving his office at the end of the normal work day, John rushed home to work on his magazine cartoons. Finding the energy to draw for four hours after a long day at work was easy for him, he says. "I was obsessed by it. I craved it. The passion was energizing."

John first became interested in cartooning due to an interest in humor. He had absolutely no art training, but funny ideas always came naturally to him. When he decided to become a cartoonist, learning to draw was very difficult for him and he admits that his early efforts were tragic. With practice and patience, his work improved, and editors soon responded to his cartoons with uncharacteristic enthusiasm. McPherson's first sales were primarily to small Christian-oriented publications, where the opportunities were many and the competition few. As he gained confidence and experience, John began to submit his work to larger publications. Eventually, Universal Press Syndicate took notice of McPherson's wild cartoons and offered him a contract for worldwide newspaper syndication and book publishing rights.

"To succeed in cartooning," McPherson advises, "you have to want it bad enough. If I won the lottery, I'd still be doing what I'm doing! Also, it's important to remember that humor is primary and the art is secondary. Read a lot of humor, be aware of humor. Observe life around you and find fun in it."

CLOSE TO HOME· JOHN McPHERSON

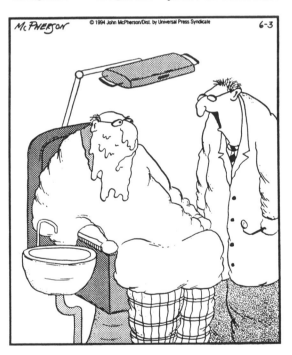

*"That Novocain should wear off
in two or three days."*

- What kind of life will I have if I don't find time to practice?
- How much extra income would I like to earn from cartooning each month?
- What will I do with the extra income when I get it? Invest it? Save it? Buy a new car? Get a bigger apartment? Splurge on a great new stereo or computer? Start a family? Buy a pack of gum?
- Where would I like to sell my cartoons? To local businesses and publications? To national publications? To greeting card companies? To a newspaper syndicate?
- What time-wasting activities can I cut back on to make more time for cartooning?
- Do I want to quit my job someday and draw cartoons at home full time?

Once you've answered these questions, it should be easy to write down a list of your goals. Put that list in a place where you'll see it every day.

Just looking at your list of goals should get you feeling more ambitious and optimistic about your future. If you're saving up for something special, paste a picture of it onto your list of goals. Once you're really excited about achieving your goals, getting organized and sticking to your plan will happen automatically!

For more detailed information on effective goal setting, consult the business or self-help section of your local bookstore or library. There are plenty of books by internationally known motivation experts like Zig Ziglar, Dennis Waitley, Anthony Robbins and others that deal with this subject very effectively.

You may find it helpful if your great-est goal is much loftier than the mere acquisition of a few material goodies. John McPherson, successful magazine cartoonist and creator of the Universal Press Syndicate panel *Close To Home*, had a big, exciting goal that made it very easy and pleasurable for him to draw cartoons on nights and weekends. His dream was to earn enough money from his cartoons to leave his day job as an engineer and freelance on a full-time basis.

"I drew cartoons for four or five hours every night after work," reports McPherson. "I couldn't wait to get home, eat dinner and get started. I was really driven, really passionate about cartooning because I loved doing it so much!"

Before long, John's creations were appearing regularly in *Campus Life, The Saturday Evening Post, Yankee, Marriage Partnership* and other magazines. Soon Zondervan Publishing contacted him for the first of eight books featuring his cartoons. After an editor at Zondervan Publishing sent a few of McPherson's books to Universal Press Syndicate, John found himself signing a contract for international newspaper syndication.

John McPherson's *Close To Home* cartoons have since become very popular and are enjoyed by millions of people every day. His experience is proof that cartooning on nights and weekends can be something to get very excited about. If you are passionate about your cartooning, you'll automatically find all the energy you need to chase your dreams.

ight now I draw cartoons just for fun and it's a wonderful hobby. But I've often

Cartoonist Profile:
FRANK COTHAM

Frank Cotham's cartoons have appeared for many years in a wide assortment of magazines and now appear regularly in *The New Yorker*, the most prestigious magazine cartoon market in the world, the one most gag cartoonists only dream about. "I worked in graphics at a television station in Memphis for thirteen years," says Cotham. "While I was there I sort of eased into cartooning, working at it whenever I had extra time. It took me two years to make my first sale and that was to *Saturday Review*. Things started picking up after that. When my regular job started to interfere with my cartoon income, I decided to go out on my own.

"I think an aspiring cartoonist should understand that making money in this business is a long shot at best and that you have to keep working at it. You can't ever sit back and think what a hotshot you are and that people are going to beat a path to your door for your work. There are lots of talented people out there. You have to love what you do. Do what comes naturally to you, rather than affect a style that is someone else's. Be persistent.

"It's scary to sit down at the drawing table and stare at a blank piece of paper and not have an idea. It happens sometimes. For me the best thing to do is just sit and doodle until something comes to mind. Anyone who wants to become a cartoonist should read as much as possible and draw every day."

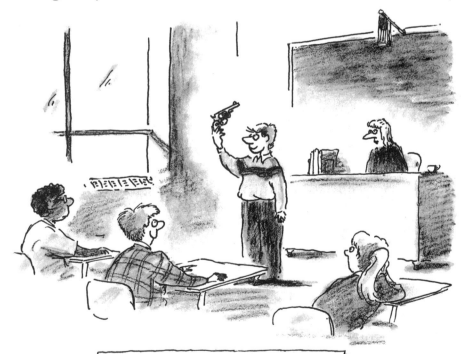

SHOW-AND-TELL

wondered what the career opportunities are for cartoonists. How much could I make as a professional?

There are several different ways to earn a living as a cartoonist. When you're good enough to go professional, you can earn a living in any of the following jobs: freelance magazine cartoonist, humorous illustrator, comic book artist, animation studio employee, freelance animator, greeting card staff artist, newspaper political cartoonist, and syndicated comic strip cartoonist.

Don't expect to get rich as a professional cartoonist. While a few famous cartoonists have become wealthy, most cartoonists earn an ordinary, respectable, middle-class income. Several well-known professionals create their cartoons as a profitable hobby, while working at another, more traditional job from nine to five.

A part-time magazine cartoonist, cartooning a few hours on nights and weekends, might earn as little as $50 or as much as $1,000 or more in a month. Someone earning the higher figure would probably have hundreds or thousands of cartoons circulating after many years of freelancing. A few magazines pay as little as $5 but the majority pay between $50 and $500 for the right to publish a single-panel gag cartoon. At these rates, the part-time magazine cartoonist can earn plenty of cash each month to supplement his regular income.

Like the part-timer, a full-time magazine cartoonist will also see his income fluctuate from month to month. One month might bring in $2,000 in new cartoon sales, another month's earnings may add up to a stronger income of $4,500, and a slow month might finish with less than $500 in new sales. Cartoonists whose work appears regularly in *The New Yorker* or *Playboy*, two of the most elite magazine cartoon markets, tend to earn more than the average magazine freelancer because these markets bring a degree of celebrity status to their artists and frequently offer lucrative contracts to their best cartoonists. Cartoonists featured regularly in *The New Yorker* also benefit from having their cartoons reprinted in other publications and are often able to sell their original artwork to collectors for a very attractive price. Most magazine cartoonists supplement their income by creating additional freelance work for advertising agencies, greeting card companies, newspaper syndicates and other publishers.

Many comic artists earn their living as humorous illustrators. A humorous illustrator is a comic artist with a distinctive style whose work is used to illustrate advertising, children's books, magazine articles, greeting cards, calendars, mugs, T-shirts, text books, and anything else that might look better with a funny drawing on it.

Some humorous illustrators clearly fit the stereotype of the "starving artist," while others can gross as much as $200,000 per year or more. While a top illustrator may earn more than some other comic artists, he must also invest more of his money to advertise and promote his services to prospective new clients. He may also budget a large part of his income for expensive computer graphics equipment and software, business trips, agents, attorneys, phone expenses, fax machines, photocopiers and other necessary business expenses.

Fees paid for humorous illustration

Cartoonist Profile:
MORT WALKER

Without question, Mort Walker of *Beetle Bailey* fame is one of the most popular and most successful cartoonists who ever lifted a pen. He has a golden reputation for being one of the busiest and friendliest people in the business. Mort is the original creator of *Hi & Lois* and *Boner's Ark* and the founder and chairman of the International Museum of Cartoon Art in Boca Raton, Florida. Prior to his mega-success in newspapers, Mort Walker was the editor of his college newspaper, an influential staff artist at Hallmark Cards, and the top-selling magazine cartoonist in America. Famous for his support of aspiring cartoonists, Walker has plenty of knowledgeable advice to offer, based on over four decades at the top of his profession.

"I wouldn't recommend too many art courses for aspiring cartoonists. You could never learn to draw arms like Popeye's in an anatomy class. The best training is drawing for school publications to see your work in print and get feedback from your schoolmates. Then study and learn everything about life you can because your ideas will come from everything you know and experience. So the more you know, the easier ideas will come. I started cartooning by copying my favorites in the funnies, so my style was con-

stantly changing. I realized that cartoons were half writing, half art, so I took as many writing and literature courses as I could.

"Ideas come easiest when I'm not distracted. I don't like to look at books or anything for stimulus because I just end up reading the book and not getting any gags. My method is to simply start writing something and letting it lead to the conclusion. If you wait for a gag to come before you start writing, you might wait all morning. I love to write and draw, so I never get tired of it. It doesn't get stale because I keep experimenting with new ideas and nuances of character. Creating ideas is exciting because you start with a blank piece of paper and an hour later you might have an idea that will live forever.

"Don't be afraid of work. You'll only succeed by working longer and harder than the next guy. Learn to take criticism. I think I've survived in this very competitive business for 45 years because I accepted the fact that not all of my ideas were gems and allowed my staff to tell me so without feeling hurt.

"You're preparing yourself for a very satisfying life behind the drawing board; one in which you can enjoy your work and make your readers happy as well. It's a good life."

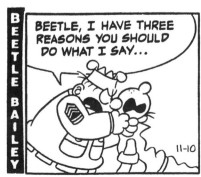
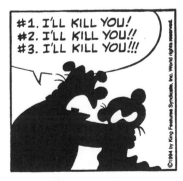

© King Features Syndicate

work vary according to the nature of the job, the usage and the client, and are generally higher than payments made for magazine cartoons. For example, an assignment for a small, color magazine illustration might pay $150, an illustration for an advertising agency might bring $1,500 or much more, a greeting card illustration might earn $300, a calendar project could pay $5,000, and royalties from a children's book could add up to several thousand dollars over the course of several years. To earn a living as a humorous illustrator, your work must appeal to a wide variety of customers and you must always be alert for potential new clients.

Comic book artists are most often paid on a per-page basis, which varies according to the title of the book, the success of the publisher, and the cartoonist's status in the field. Beginners tend to produce fewer pages per week and earn less than more experienced comic book artists who are able to finish work faster and produce a higher volume of pages. Like any other cartooning specialty, the comic book industry does have a few superstars, such as Curt Swan, John Romita or the late Jack Kirby, whose celebrity status brings them an income higher than the rest of the crowd.

A cartoonist working on staff for an animation studio or greeting card company can generally earn a solid middle-class living at salaried or hourly wages with some employee benefits. Beginning salaries generally average somewhere between $300 and $600 per week for greeting card artists and tend to be a bit higher for artists entering the animation field.

Salaries paid to greeting card or animation employees will vary according to the cartoonist's level of experience, length of employment, and the economic status of the employer. The greatest benefit of working on a salaried staff is financial security and stability, something that freelancers can never be entirely sure of. For the sociable artist, there is also the chance to work in a energetic atmosphere surrounded by other creative people.

A political cartoonist creates daily editorial cartoons for newspapers. A cartoonist working for a small city newspaper may earn a very modest income, while a very successful political cartoonist working for a large metropolitan newspaper may be rewarded for his Pulitzer Prize winning work with an attractive salary and benefits package. If a political cartoonist's work is resold to other newspapers by a syndicate or is reprinted in important weekly news magazines, he will receive royalty payments for each additional usage, and these checks can greatly increase his total annual income. Most political cartoonists are paid salaries similar to those paid to editors and reporters, and their duties may also include creating other pieces of art to meet the newspaper's illustration needs.

By far the greatest earning *potential* for any cartoonist is newspaper comic strip syndication. Getting your cartoons distributed by a newspaper comic syndicate like King Features Syndicate or Universal Press Syndicate is a very difficult task and the competition is overwhelming, but the rewards can be extraordinary. A syndicated cartoonist with a very popular comic strip, such as *Garfield* or *Peanuts*, can earn millions of dollars annually from newspapers, toys, movies, clothing, books, calendars, TV

Cartoonist Profile:
BRIAN CRANE

Pickles, by Brian Crane, is considered by many to be one of the funniest and most charming newer comic strips in newspapers today. Despite an initial period of discouragement and rejection, Crane overcame the odds and is now enjoying all the rewards of successful comic strip syndication.

For years, Crane worked at an advertising agency and his cartooning career was nothing more than a daydream. To avoid a major mid-life crisis at age forty, he realized that it was time to stop daydreaming and time to take some action. "My problem was that I never figured I was good enough or funny enough to do a comic strip, so I never bothered trying to do one until I was in my forties. I wish now I had tried it twenty years ago. Getting syndicated wasn't as hard as I thought it would be.

"Mostly I just drew as a kid. I bought all the Walter Foster books on cartooning and practiced drawing the pictures in them. I doodled constantly on my school note papers. I majored in art in college, but took mostly fine art classes. Walt Disney and Warner Brothers cartoons were also a big influence. Add to that list *Lil Abner* and *Pogo* comic strips, as well as *Peanuts* and *B.C.* I loved Al Capp's mastery of anatomy and the quality of his ink lines, and used to try and copy his style. I was never able to do it like he did, but it was good practice.

"Don't let a day go by without drawing something. It doesn't have to be a cartoon drawing, either. I think the ability to draw well realistically makes it easier to draw cartoons that don't look amateurish. Also, practice your lettering. You can have the funniest cartoon in the world, but if no one can read it, it's a waste of time."

Like most cartoonists, Brian has his own favorite way to get funny cartoon ideas. "I keep a small metal box on my drawing board in which I put little scraps of paper with ideas on them that I have jotted down whenever they occurred to me. I look them over to see if any of them click. If not, I try brainstorming, writing possible lead-in sentences to a gag. If nothing seems to be working, I hop in my truck and go for a drive. Quite often that's when an idea comes to me."

Pickles by Brian Crane

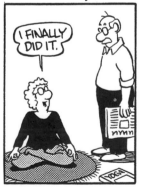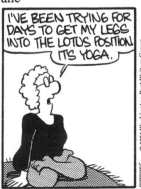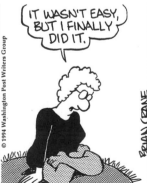

© 1994, The Washington Post Writers Group. Reprinted with permission.

shows, greeting cards and more. On the other hand, some syndicated comic strip artists actually earn less than $100 a week from their creations if their work appears in only a handful of newspapers.

To enjoy a comfortable living from syndication, a cartoonist's comic strip or single-panel cartoon must appear in approximately 100 or more newspapers, including a few with a large circulation. The more newspapers a cartoonist's work appears in, the more he will earn. A successful cartoonist with a comic strip in 300 newspapers, for example, could be earning $60,000 to $150,000 per year or more, depending upon the circulation and payment rates of the newspapers that publish the strip.

Unfortunately, the comic strip field is very crowded and it has become increasingly difficult for new cartoonists to get their strips into a long list of newspapers. Fewer syndicated cartoonists today are earning the big money while more and more are enjoying a more modest, middle-class living. Several well-known comic strip artists, such as *Dilbert* creator Scott Adams, continue to work at a nine to five job while creating their popular comic strips on nights and weekends. This shields the cartoonist from some of the insecurities of syndication, where the cancellation of a single large client newspaper can cost a cartoonist as much as $400 a month or more in lost income.

There are many rewarding ways to earn a living from cartooning. Most great cartoonists confess, however, that they aren't in it for the money. Most do it because they love to create funny cartoons and couldn't imagine doing anything else for a living.

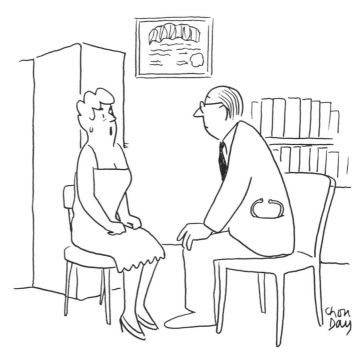

"Now just a darn minute! Your second opinion is exactly the same as my doctor's first opinion."

Legendary magazine cartoonist Chon Day began his professional cartooning career in 1929, in the financially troubled days of the Great Depression. "I sold cartoons to many magazines, they paid $3 to $5 per cartoon, which was more than the bankers got for selling apples on the street corners back then. In the sixty-five years I've been selling cartoons, my enthusiasm has never dwindled—I love to draw. I even doodle on the placemats when I'm out to dinner! I think great art is one hallmark of a great cartoonist. George Price and Peter Arno had wonderful line work.

"*The New Yorker* work I did started when I kept taking sketches to them weekly. They bought just the *ideas* from me and gave some to Peter Arno and others to draw. Finally the publisher said to Jim Geraghty, the cartoon editor, 'Let's try some of Chon Day's work.' That's how I got my foot in the door. I still have a contract with them."

Now in his late eighties, Chon Day has absolutely no plans for retiring. "I expect to keep drawing as long as the old pen works!"

I s it possible to be too young or too old to start cartooning?

If you drool on the paper, are too weak to hold a pencil and keep falling off the chair, chances are you may be too young to start cartooning. Aside from that, nobody is too young to begin enjoying the fun and rewards of cartooning. While years of experience

arty Bucella has been one of America's most widely published magazine cartoonists since the late 1970s and has enjoyed syndication with his *Sports Hall Of Shame* feature for Tribune Media Services. Over the past twenty years, thousands of his cartoons have appeared in *The National Enquirer, Good Housekeeping, New Woman, Going Bonkers, Woman's World*, and nearly every magazine in North America that publishes spot cartoons.

Bucella began cartooning in high school, doodling in notebooks and drawing for fun. While in college, he discovered that his homemade greeting cards were a good way to impress girls, so he decided to submit several of his samples to publishers. Although his cards didn't sell, it wasn't long before he was finding some fledgling success, with a few small sales, as a magazine cartoonist.

Marty Bucella's father had made an unsuccessful attempt at cartooning many years earlier and was very supportive of Marty's early efforts. Following graduation from the University of Buffalo with a B.A. in geography, Marty continued to live with his parents for four years as he established his cartooning career. "Without my parents' support, I never could have begun a freelance career," he recalls. "My first year I only made about $1500, but for the next few years after that my income doubled each year. After four years I was grossing enough to leave home, get married and make it on my own as a cartoonist."

Sports Hall of Shame by Nash & Zullo

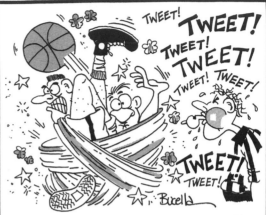

THE ARIZONA WILDCATS AND NORTHERN ARIZONA LUMBERJACKS CLAWED, HACKED AND SCRATCHED EACH OTHER IN THE FOULEST BASKETBALL GAME IN NCAA HISTORY. IN THEIR 1953 BATTLE, WON BY ARIZONA 90-70, THE WILDCATS COMMITTED A RECORD 50 FOULS TO NORTHERN ARIZONA'S 34. THE COMBINED 84 PERSONALS SET A COLLEGE BASKETBALL RECORD FOR MOST FOULS IN A GAME.

4-5

and practice are certainly an asset to cartooning, a few cartoonists, such as *Beetle Bailey* creator Mort Walker, began selling their work professionally while still in high school. Many other successful cartoonists have entered the profession while in their twenties, fresh out of college. If you enjoy drawing cartoons for fun, you're never too young to impress friends with your funny characters and you'll get plenty of attention drawing cartoons for posters, bulletin boards or school projects.

Conversely, nobody is really too old to start enjoying the fun and rewards of cartooning. Many very famous cartoonists did not make their claim to fame until they were well over thirty years old. (In fact, it is quite rare for *any* cartoonist to achieve a high degree of success before his thirtieth birthday. Like it or not, it takes time to achieve greatness!) Jim Davis first introduced the world to *Garfield* when he was 33 years old. Bil Keane's *Family Circus* did not debut until after his 38th birthday. Bill Hoest was 42 when he first found success with *The Lockhorns*, Bud Blake was 47 when he began the strip *Tiger*, and Bob Thaves had a long career as an industrial psychologist before he created *Frank and Ernest* at age 48. Several famous cartoonists have remained at the top of their field well into their sixties and seventies, with little thought of retirement. Clearly, cartooning is a career or hobby that can be enjoyed by anyone at any age.

"My name is Fred, but most people call me 'Oh no, not you again!' "

Bob Vojtko works in a supermarket during the day and moonlights as a magazine cartoonist on nights, weekends and even during his lunch hour. Despite his full-time job, he finds time to create as many as one hundred new cartoons each week by following a very strict schedule for his freelance work. It's easy for him to get excited about his cartooning because he often earns as much from his freelance work as he brings home from his real job. Bob's cartoons have appeared in *The National Enquirer, Good Housekeeping, Woman's World, Cortlandt Forum, The Globe,* and many other well-known publications. At one time, Bob also illustrated the *John Darling* comic strip for the North America Syndicate. Vojtko is assisted by his wife, Sue, who mails out stacks of cartoons each week, keeps track of billings and payments, and even writes a number of the gag ideas that Bob uses in his cartoons.

For practice, I've always doodled and sketched my cartoons in pencil. What sort of artist supplies should I use if I want to make my work look more professional?

The tools of professional cartooning are as varied as the cartoonists themselves. *New Yorker* cartoonist George Booth has said that he draws his famous cartoons with nothing fancier than a black ballpoint pen. Jack Tippit, who for many years drew the syndicated comics *Amy* and *Henry*, claimed to do much of his inking with a common wooden toothpick instead of a pen. Rick Kirkman, artist for the popular *Baby Blues* comic strip, prefers to "ink" his cartoons with a black colored pencil.

Despite their diversity, most cartoonists begin their drawings with an ordinary #2 pencil; some use fancier, expensive pencils from an art supply store. The most commonly used pens are flexible metal points dipped into India ink, although felt-tip pens are also becoming very popular with many professionals. A few cartoonists prefer to ink their work with a red sable brush instead of using any sort of pen. The different papers and illustration boards used also vary from cartoonist to cartoonist. Computers are being used by more and more cartoonists, primarily as a tool for coloring and lettering.

When selecting the tools you want to use for your cartoons, the most important criterion is quality of reproduction. Professional cartoonists are creating drawings that will be published in magazines, newspapers and other media, so the art must print clearly. Clear reproduction means pen or brush lines that are dark enough and thick enough to show up when the art is photographed or scanned and reduced for publication. Whether you're creating cartoons for a small local advertiser or for the world's next great comic strip, quality tools will help you achieve quality reproduction.

There are two easy ways to discover and obtain the professional tools of cartooning: browsing in art supply stores and through art supply catalogs. To find a good art supply store near you, look in the yellow pages. Call a few stores and find out whether they specialize in commercial or fine art supplies. While fine art supply stores may have a few items you can use, they tend to specialize in oil paints, canvases, acrylics and other painting supplies. A good commercial art supply store is more likely to have the pens, brushes, inks, markers, papers, boards, pencils and erasers you need for quality cartooning. They may also sell drawing boards, lamps, art instruction books and other accessories you might want to invest in. To obtain a few good art supply catalogs, look in the back pages of *The Artist's Magazine* for classified ads of mail-order distributors.

GLASBERGEN

"We better go home now, Dad. Your Silly Putty is starting to melt."

There are so many different pens and brushes and markers to choose from, I don't know where to begin! How can I discover which tools are right for me without going bankrupt buying every sort of thing to experiment with?

When you're ready to create professional-looking cartoons, begin with a few basic, inexpensive tools and slowly try out new materials as you can afford them. To get started, go to an art supply store or stationery shop and look for a small sampler set of pens and pen points, all collected together in one bargain-priced package. These starter sets offer the beginner several pen styles to experiment with, and most collections feature the most popular and commonly used pen points. The Speedball Cartooning Set from Hunt Manufacturing, for example, contains two pen point holders and six different pen points. Each pen point in this set varies in line thickness and flexibility, including pens for drawing as well as pens made especially for cartoon lettering. Be sure to also buy a bottle of black India ink to

Cartoonist Profile:
JERRY SCOTT and RICK KIRKMAN

Written by Jerry Scott and drawn by Rick Kirkman, *Baby Blues* is one of the most popular strips from Creators Syndicate. Jerry and Rick both grew up dreaming about becoming successful cartoonists and were eventually introduced to each other as the result of a friendship between their wives. After several unsuccessful collaborations, *Baby Blues* brought the team the sort of fame and rewards they'd been reaching for.

"Before *Baby Blues*, Rick and I were searching for an idea for the world's next great comic strip," recalls Jerry, "trying all kinds of ideas, but nothing was working out. Our biggest mistake was concentrating on the setting and circumstances instead of the characters. At that same time, Rick had recently become a father and was always going around with baby food stains on his shirt and talking about how little sleep he got last night because the baby was up all night. He was full of funny stories about the joys of parenthood. Suddenly we realized that we had a great strip idea right under our noses.

I'm convinced that great strips and characters aren't *created*, they're *discovered*! There's a whole lot of material lying around in everybody's living room that they just don't see. The whole world is full of funny stuff!

"To get ideas for *Baby Blues*," Jerry explains, "I drink a lot of coffee and do some research in baby books or magazines, make notes about babies throughout the week. I try to write eighteen to twenty gags from which Rick will pick two weeks' worth of ideas to draw." The remainder of Jerry Scott's time is spent writing and drawing the classic *Nancy* comic strip for United Features Syndicate.

Before collaborating with Jerry Scott, Rick Kirkman was employed as an artist in an advertising agency and later freelanced as a humorous illustrator. Throughout his earlier career, Kirkman was never comfortable with the traditional cartooning tools of pen or brush and black ink, so he began using black colored pencils, which help give *Baby Blues* its very distinctive look. Beginning with a pencil sketch on tracing

Nancy reprinted by permission of UFS, Inc.

paper, Rick uses a light box to trace the final art onto heavier paper for the finished art.

Both Kirkman and Scott are aware that the comic strip business is not quite the same as it was when they were kids dreaming their dreams of glory in the 1960s and 1970s. "Our expectations were based on older cartoonists who built their careers in the 1950s and 1960s," says Kirkman. "Back then comic strip cartoonists were stars with very high incomes. Financial realities just aren't that way anymore. For the majority, comic strip success today is clearly a middle-class situation."

Jerry Scott agrees. "The newspaper market has changed, it's smaller. Anyone under forty years old seems to be doing more than one thing, strips, freelancing, editorial cartoons or whatever. Most people with strips in fewer than two hundred newspapers are doing more than one job."

Rick Kirkman believes that originality is one key to becoming a great cartoonist. "The great ones do something totally different, create something completely unique. Luck also plays a role. You can't force the public to love your work and luck isn't something you can control or manipulate. However, you can never be lucky unless you work hard and are prepared when luck arrives!"

Jerry Scott sees greatness in a slightly different way. "Greatness in cartooning is a matter of integrity, sincerity, genuineness. With the great ones, it's clear that they are always doing their absolute best work, never coasting or taking the easy way."

As a message of encouragement to aspiring cartoonists, Jerry Scott offers a few words of advice. "Always do your very best work, and keep working at getting better. Be honest with yourself. Be real, don't try to do something just because you think it will sell. In other words, don't be contrived. Be yourself and do work that is uniquely your own."

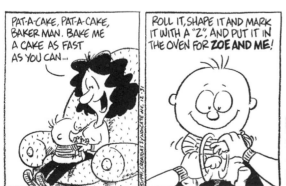

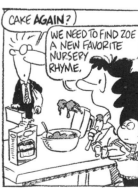

By permission of Rick Kirkman, Jerry Scott and Creators Syndicate. © 1994 Creators Syndicate.

These lines were created with a variety of different tools. From top to bottom, they are: Paper Mate Flair pen, Hunt 107, 108, 100, 103, Speedball B-5, B-4, no. 1 red sable brush, no. 3 red sable brush. There are all sorts of other markers, pens, brushes, high-tech mechanical pens, and brush-tip markers for you to try. Each pen has its values and limitations. By experimenting with many different tools, you'll discover what works best for you and your style.

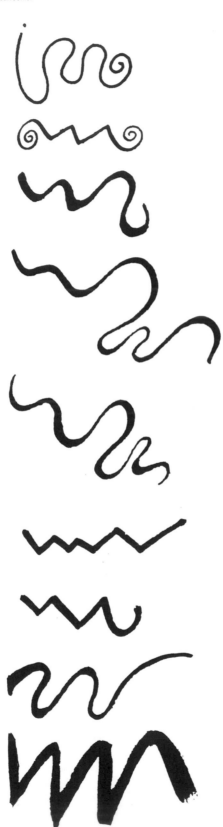

dip your pens into, since this type of pen does not contain its own ink as felt-tip and ballpoint pens do.

Brushes are also worth experimenting with, but usually require more practice than a pen. Cartoonists who use a brush to ink their work get wonderful results with a wide variety of thin and thick lines and a three-dimensional quality that is not possible with many pens. Most professionals use red sable brushes which, like pens, come in a variety of different sizes. Buy one or two different sizes to begin with and see if you like them. A no. 1, no. 2 or no. 3 brush would be a good choice for starting out. Be sure to tell the art supply clerk that you're using the brushes for India ink work; otherwise he may try to sell you brushes that are better suited for oil painting or other types of work.

When you're ready to experiment with fancier pens, such as Rapidograph technical pens, just buy one to see how well you like it. You don't need to invest in an entire set of expensive pens right away. If you're in an art store, ask the clerk if he has a demonstrator that you can try out before you buy.

If you're just getting started and have a tight budget, you can create wonderful cartoons with nothing more expensive than a common black Flair pen from your neighborhood grocery store. In fact, all of my cartoons in this book were inked with this type of pen. Unfortunately, the tips of these pens get broad and mushy rather quickly, and the pens must be replaced often to keep a sharp and attractive line.

As you begin to collect the tools of the trade, start small, experiment, and gradually gather more tools as

you grow. Small investments, made frequently, can quickly add up to a large supply of tools and materials.

What sort of paper do professional cartoonists draw on❓

Professional cartoonists use many different types of paper for different effects and purposes. The type of paper you need will depend on the type of work you plan to do. All of the papers you will use can easily be obtained from any art supply catalog or store.

Most magazine cartoonists draw their gag cartoons on standard size 20-pound or 24-pound typing paper. This paper is durable enough to survive many mailings to different magazine markets, but light enough to mail several cartoons together inexpensively. This sort of paper is generally known as bond paper or parchment deed paper and can be found in any good office supply store in boxes of 100 or 500 sheets.

Comic strip cartoonists and political cartoonists create work that is usually larger than a typical magazine cartoon, so their work most often is drawn on strips of paper cut from larger sheets of special artist paper called bristol board. Bristol board is a heavy paper, as thick as or thicker than a postcard, and is very well suited for brush and pen work. Bristol board comes in large individual sheets or in pads and is available in different thicknesses and textures. A plate finish means your bristol board has a smooth texture and is easy to drag a pen point across. A vellum finish has a bit of texture and friction to it and is good for brush work.

One specialty paper that a few comic strip artists and many political cartoonists enjoy using is called Duoshade. Sheets of Duoshade board are printed with an invisible dot or line pattern that appears when a special developing solution is brushed on. This pattern gives your work a shaded effect without using gray ink or markers, and reproduces quite well when printed on cheap newsprint.

Humorous illustrators, children's book illustrators and greeting card artists may use the same paper and boards that comic strip artists and magazine cartoonists use, or they may experiment with other papers, depending upon the particular needs of a project. An illustrator working with an airbrush would probably use a heavier bristol board, but someone creating loose greeting card sketches may be comfortable with a much lighter paper. Each project may require the use of a different type of paper. For rough sketches and preliminary drawings, most professionals

There are many different ways to apply gray areas to your cartoons. For newspaper strips, most cartoonists use some form of shading screen, a plastic sheet of a dot or line pattern with an adhesive backing, which can be cut out and stuck to your drawings. Some cartoonists now scan their art into a computer and apply shading screen (and other halftone effects) electronically.

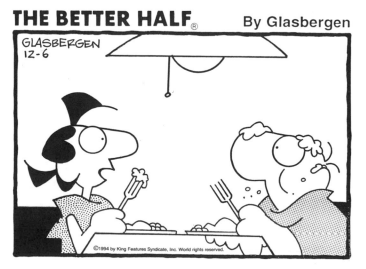

THE BETTER HALF® By Glasbergen

GLASBERGEN 12-6

"You're such a slob when you eat! You're the only person I know who has to floss his eyelashes after meals!"

use nothing fancier than a pad of newsprint or layout paper.

There are many different types of paper to try. Art supply catalogs give detailed descriptions of each product and are the best sources for exploring the possibilities.

Pencil lines can easily be erased, but how do I fix a mistake made in ink**?**

Even the best cartoonists need to make corrections on their ink drawings once in a while. Actually, many cartoonists need to fix little mistakes on just about every drawing they create. Some cartoonists touch up ink errors with white watercolor paint from a tube. Others cut a patch from a clean sheet of paper or art board and paste it over the error, redrawing on the patch if necessary.

One of the most common ways to cover up an erroneous ink line is common, ordinary correction fluid, such as Liquid Paper. There are several different types of Liquid Paper available for a variety of purposes. Original Liquid Paper in the black-and-white plastic bottle works great on felt-tip pen lines, but you may need to experiment with other Liquid Paper formulas to find the best cover-up for the type of pen and ink you use. There are cheaper brands of correction fluid available, but they tend to be too thick for the cartoonist's special needs and generally inferior.

While ink mistakes will occur from time to time, many can be avoided by being especially careful to get your drawing as perfect as possible during the layout and penciling stage. Rushing to the inking stage too soon can contribute to unnecessary mistakes and poorly planned changes.

Magazine cartoonists often use diluted black ink or watercolor to create a gray wash to add shading to their cartoons. Others achieve this effect by rubbing the side of a lead pencil on their drawing, blending and smoothing it with a tissue, then spraying it with fixative to prevent smearing. In this cartoon, a gray marker was used. Experiment with a variety of shading methods before becoming locked into any one.

"On our wedding day, you really looked fabulous! Why don't you dress that nice every day?"

Some magazines print cartoons in color. What sort of paint or markers should I use if I want to try adding some color to my cartoons❓

Once again, experimentation is the best way to learn. Many cartoonists color their work with concentrated watercolor dyes that come packaged in small jars slightly larger than ink bottles. Two popular brands are Dr. Ph. Martin's and Luma. These bright colors can be used straight from the bottle or diluted with water to tone them down and are easily applied with a brush. You might also want to experiment with designer's gouache, a thick paint in a tube which can be diluted and applied to your cartoons or illustrations with a brush.

Whenever you use any type of watercolor paint or dye, be sure your black line cartoon has been inked with waterproof India ink—otherwise the colors will cause your line art to smear, fade or blur. You must also use a paper or board thick enough to accept watercolor without curling up or flaking apart. A two-ply bristol board is thick enough for small spots of watercolor, but three-ply is better for larger areas of color which are more apt to saturate the paper.

Markers are another popular, fun and easy way to color your cartoons. Markers can be used with India ink drawings or with felt-tip pen line art without causing your ink to smear. While markers can be used on a variety of papers, you will probably get your best results when using a thin paper created especially for markers. Marker paper will accept marker without the ink fading or spreading, so your finished work will be bright and crisp looking. Many companies sell art markers in sets ranging from 25 to 150 different colors. Be sure to get your markers from a good art supply store or catalog since these markers are not the ones you would buy from a stationery or department store for arts and crafts or church posters. Try to use your markers in a well-ventilated area because many brands give off an unpleasant odor.

Colored pencils can add extra detail and texture to your watercolor or marker art. After your ink and paints are completely dry, draw a plaid pattern on a shirt, add some flowers to a dress, sketch a few blades of grass against a lighter green background, put a design on a sofa, or add a few strands of hair to a dog's back. Colored pencils give you control over small details in a way that isn't always possible with a brush or marker.

Consider learning how to use an airbrush. An airbrush applies color in an aerosol fashion, much like spray paint only more controlled. While airbrushing takes practice and patience, the results can be very attractive. Most airbrushes are made to be used with paint; some, however, are now made for use with markers as well.

As your learn to create cartoons in color, become more aware of the color cartoons you see in magazines and greeting cards. Study them, tack a few to your bulletin board, and allow yourself to be influenced by different color styles. If you have little or no formal art training, read books on painting and color technique, or sign up for an art class. Books worth looking into include *Exploring Color* by Nita Leland and *Getting Started in Airbrush* by Dave Miller and Diana Martin from North Light Books.

Cartoonist Profile:
PAT BRADY

Pat Brady uses several different tools to create the wonderful art for his comic strip *Rose Is Rose*. As a result, his drawings are the envy of many fans and professionals. "I use a no. 10 Grumbacher brush for some characters' hair and for large solid black areas. I used to use a felt-tip Flair pen for lettering, but the original art would fade away, so I've switched to a Pigma Micron pen. It's as easy to use as a Flair, but the art supply dude told me the lines would last forever. For the rest of my drawing I use my own creation, a giant Frankenstein pen I created from bits and pieces of other pens, such as the point of a discontinued Koh-I-Noor fountain pen and the handle from an old Rapidograph I liked. My preliminary work is done in blue pencil, so I can ink right over it without erasing later."

Brady has no formal art training in his background, aside from a few sketching classes. He was never an assistant or apprentice to any other cartoonist and is virtually self-taught as an artist. "I was heavily influenced by those small pocket-size books of *Mad* magazine reprints as a kid, especially the work of Will Elder." Pat recalls. "In fact, the very first submission of my work was to *Mad* magazine when I was eleven years old. I was also influenced by Al Capp's *Lil Abner*."

Pat Brady's first comic strip, *Graves Inc.* (a strip about office life and big business) was syndicated by The Register and Tribune Syndicate, but unfortunately its sales were dismal and disappointing. After three years of syndication, *Graves Inc.* ended and Pat feverishly labored to create something new to get his career back on track. Instead of wallowing in self-pity, he almost immediately rushed out four new comic strip concepts, one of which was *Rose Is Rose*. Rose and her family quickly caught the attention

ROSE IS ROSE is reprinted by permission of UFS, Inc.

of editors at United Feature Syndicate. While Brady is considered by many to be one of the finest artists in the business, his initial submission of *Rose Is Rose* featured short 'nebbish' creatures, similar in style to outdated greeting card characters. Although the original concept was quite different than it appears today, *Rose Is Rose* has gone on to become a solid and lasting success in syndication.

Pat Brady has found that good habits are very helpful in the creative process. "I write my ideas in the morning when I'm freshest. I keep a tape recorder with me all day in a fanny pack. When I think of an idea or hear a word or phrase that suggests something I can work into an idea, I'll record it on the tape. Over the course of the day, I'll collect several verbal notes I can work with the next morning. Art is much more fun to me than ideas. Writing is always more of a struggle for me. I drink coffee while I write, and I also find that it's helpful to exercise regularly."

To keep his enthusiasm after years of creative output, Brady has found a way to keep his work fresh and exciting. "I'm always trying new things with my art, new angles, new perspectives and new visual points of view. I'm always trying new materials, new paper and new pens. I have to produce on days when I'm enthused as well as days when I'm not enthused at all. Some days it's simply a matter of perseverance. Other times it goes almost effortlessly!"

Pat Brady doesn't believe there is any real secret to success in cartooning. "I think it's mostly a matter of determination and a willingness to keep trying, because you're going to fail a number of times before you succeed. I also think it's important to treat the people you deal with with honesty, sincerity and respect."

This computer-enhanced cartoon was created by John Locke. "I usually draw the cartoon by hand, then scan it into the computer and use a paint program to add shading, depth, and even reflections. I recently acquired a digitizing tablet which enables me to draw directly into the computer. In my studio, the computer is the drawing board. I think this is the exception, but someday, as the computer generation graduates from high school and college and enters the market . . . well, then my situation may not be so unique."

Now that desktop publishing has become so popular, do cartoonists need to use computers to create their cartoons**?**

Although a growing number of professional cartoonists are using computers in their studios for a variety of creative and business purposes, computers are by no means mandatory. Good quality cartoons created at a drawing board are still very much in style.

With rare exception, most successful professional cartoonists are still creating cartoons the old-fashioned way with pen and ink on paper. While many are experimenting with Macintosh and other computer platforms, an adjustable wooden drawing board is still more valuable to most cartoonists than any scanner, monitor or fancy software program.

Computers are fun and exciting to work with, but they cannot create great cartoons all by themselves—not yet, anyway. Computers are only a tool. Just as an expensive pen won't make you a great cartoonist, an expensive computer won't either. *The tools that are used are never as important as the person who is using them!*

If some cartoonists are using computers now, what sort of hardware and software do they use and how does it affect their work**?**

Computer use among professional cartoonists is increasing rapidly, and computers are becoming quite commonplace in the professional cartoonist's studio. For most cartoonists and illustrators, Macintosh-compatible computers are the preferred platform. Specific hardware and software brands are a matter of preference and vary from artist to artist, depending on the specific needs, goals and budget of the cartoonist.

Typically, a good computer graphics system would include the following items: a fast computer with a minimum of 16 megabytes of RAM and at least 500 megabytes of hard disk memory, a keyboard, a color monitor (the size of the monitor will depend on your needs and your budget, but bigger is always better), a high-resolution color flatbed scanner, a 600 dpi laser printer, and some type of removable

Fractured Facts John Locke

As Herb hustled across the dance floor, he was unaware that most people considered him a has-been.

hard drive for storing and transporting large digital files on disk.

A modem is also valuable, giving you the ability to rapidly deliver your art to publishers electronically. A computer with a modem will also give you access to the information superhighway. Cartoons are becoming a very popular feature on the Internet, and many companies on the World Wide Web now use cartoons to attract people to their pages. The Internet is an important new frontier for cartoonists to explore and has the potential of becoming the next big marketplace for all types of cartoons.

A well-equipped computer should also include a CD-ROM player, which can put an entire encyclopedia and other resource materials at your fingertips for instant access.

High-resolution color printers are becoming more affordable and many cartoonists and illustrators are using them to print full-color samples of their work for portfolios and other presentations.

Basic software needs for the cartoonist include Adobe Photoshop for processing scanned art, a simple layout program such as ClarisWorks, and some sort of word processing program like Microsoft or Word or WordPerfect. For more in-depth art, a computer illustration program such as Adobe Illustrator or Aldus Freehand would also be essential. Additionally, there is a multitude of specialty programs available in software catalogs, programs which allow you to color your work, animate it, make it three-dimensional, add textures, enhance and distort images, use type creatively and design exciting layouts featuring your cartoons or illustrations. It is no exaggeration to say that the

Al's part-time job is beginning to interfere with his school work.

possibilities are endless!

As electronic publishing becomes more and more commonplace and magazines continue to expand into the CD-ROM format, animated magazine cartoons are a new frontier for freelancers to explore. Some freelance cartoonists have begun to experiment with fairly inexpensive animation software to create a whole new style of magazine cartoon. Comic book publishers are also experimenting with new methods to accommodate CD-ROM publishing, and many animation studios like Disney have been using computers in a variety of creative ways for years.

A rapidly growing number of comic strip artists are now using computers to do their lettering for them, saving them many long hours of tedious pen work. Popular programs such as

In this gag cartoon created for magazines, the lettering appears to have been done by hand. Actually a commercially available lettering font installed in a Macintosh computer was typed onto the layout for this cartoon, then printed on a laser printer. Later the art was added to the layout at the drawing board. Special cartoon-style lettering can be printed directly onto your drawing paper or can be pasted into your drawing separately. More and more cartoonists are now using computers to do the otherwise tedious task of lettering.

Cartoonist Profile:
JOHN CALDWELL

John Caldwell has been very busy as a cartoonist and humorous illustrator since the early 1970s. He has created many classic cartoons for *The National Lampoon*; his comic panels have been syndicated internationally by King Features Syndicate and turned into a cartoon-a-day desk calendar; his book of faxable cartoons and messages, *Fax This Book*, has been a great success and spawned a follow-up book, *Faxable Greetings*. Now John is probably best known for being a member of *Mad* magazine's famous "Usual Gang Of Idiots."

Caldwell never received any actual training as a cartoonist, but did attend the Parsons School of Design, where his general art education helped him prepare for his cartooning career. "You first learn the rules, then you learn how to break them" is how John explains the value of art school to a comic artist. "Since *cartoonist* is such a broad term, there are specific areas where training would be essential—if someone were interested in animation for instance. But as for pure drawing style, I think that comes from within. Your brain takes in a blend of influences and the result eventually comes out the tip of whatever implement you happen to be holding in your hand. It doesn't happen overnight, so get some sleep."

Despite more than twenty years in the business, the creative process is still a challenge to Caldwell. "The stuff I do for *Mad* generally starts with a single premise. For instance, a while back I did an article titled 'Gross And Beyond Gross.' That started from a single thought: 'Gross is guys who don't trim their nose hairs . . . and beyond gross is guys who braid them.' I liked that premise so I wrote and did rough sketches for another twelve or fifteen and submitted them to *Mad*. They narrowed it down to eight and I had a two-page spread. Although I see the concepts in my head, I usually start with the writing.

"To help me get going I like to exercise and drink caffeinated beverages. I ride an exercise bike for about 45 minutes in the morning. I usually use that time to read the paper or a book or magazine. I try to get myself thinking funny. As I read I'm looking for something I can use in a cartoon. Actually, I think exercising your brain at the same time as your body may actually burn more calories than using a Nordic Track while listening to George Jones or watching professional wrestling. If I'm having a hard time thinking funny I also like to read certain humorists like S.J. Perelman or Woody Allen. I find that generally snaps me into a reasonably goofy mood."

Despite some gloomy predictions by others, Caldwell is optimistic about the future of freelance cartooning. "I used to say the gag cartoon markets are drying up. In fact, that's not true. They're not disappearing as much as they're changing form. Today's periodical may end up on tomorrow's computer network. A book idea may instead take the shape of a CD-ROM. The point is, it's a good idea to be aware of which direction the communication industry is headed. Whether we resist the change or not, we're going to be swept along with the rest of humanity. Might as well try to benefit from it. Another thing, be diverse. Try different media, different markets. Don't hang all of your hopes on a one-trick pony."

© John Caldwell

Fontographer and Personal Font can be used to recreate a cartoonist's own personal lettering style, changing it into a computer font which can be typed on a keyboard, printed out on a laser printer, and pasted onto the cartoonist's original comic strip drawings. Several hand-lettered fonts can also be found in various commercial font collections and can be downloaded as shareware from online services such as CompuServe and America Online. While this method of comic lettering does add a degree of unnatural uniformity to the words, it looks very much like it was written by hand and most readers would never suspect that any part of the comic strip was affected by a computer in any way. In fact, many of the comic strips you read every day have been using computerized lettering for years and it's quite possible that you've never even noticed . . . until now.

For many cartoonists and illustrators, the computer has become the tool of choice for creating color work. The computer gives cartoonists color effects that simply aren't possible with watercolor, markers or any other media. Publishers, designers and layout people often prefer to receive color cartoons on disk because this can save them the trouble of scanning and preparing original artwork for publication. Programs such as Photoshop, Color-It and Adobe Illustrator make it easy for cartoonists to add color to scanned black-and-white art using a digital graphics tablet and stylus. At first, learning the basics of computer

This cartoon of *The Better Half* was created on a photocopier, a Macintosh computer and a drawing board. First a template of the title, byline and border was photocopied onto a sheet of 24-pound parchment deed bond paper. Next, the caption was typeset using a computer, and spelling was automatically checked for errors in a word processing program. After the caption was printed on a laser printer, it was pasted onto the cartoon beneath the border. Finally, the drawing was penciled by hand at the drawing board, inside the preprinted border, and the final inking was done with a Flair felt-tip pen.

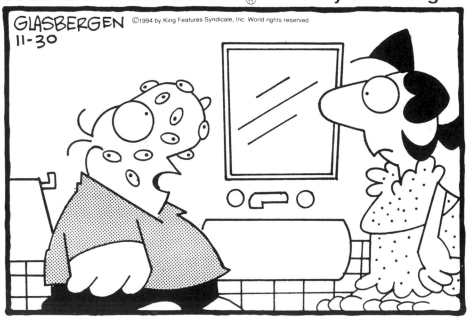

THE BETTER HALF® By Glasbergen

GLASBERGEN 11-30 ©1994 by King Features Syndicate, Inc. World rights reserved.

"I must have eaten way too many hors d'oeuvres at the party. My face is breaking out in olives!"

Frank and Ernest

YOU SHOULD HAVE MADE THEM PUT UP A DAMAGE DEPOSIT.

THAVES 4-1
© 1994 by NEA, Inc.

E-Mail: FandE BobT@AOL.COM

graphics can be challenging, but the results are worth the effort. While computer graphics are often criticized for being a substitute for "real art," it is important to understand that the computer does not do your work for you any more than a paint brush does your work for you. The computer is just another tool at your disposal.

If you want to learn more about computer graphics and animation, spend some time in bookstores and libraries. Look for *Getting Started In Computer Graphics* by Gary Olsen (North Light Books). Also, buy a few issues of some top computer magazines like *Mac World, Wired, Mac User* or *Mac Home Journal* to better acquaint yourself with graphics computers and their usage. But remember: the computer will not make you a great cartoonist—it is only a tool that can help you explore and express your own greatness!

What kind of reference materials should I have in my studio?

Reference materials are important to any cartoonist. An extensive reference file of photographs, often referred to as a *morgue*, can help you

With permission of Bob Thaves.

Bob Thaves uses a computer to do all of his lettering for *Frank & Ernest.* His personal comical hand lettering of the alphabet was programmed into his computer as a font, which is typed from his keyboard and pasted into his comic strip panels. While all of his actual drawings are done by hand at the drawing board, he occasionally uses his computer to add shading to characters and backgrounds instead of using hand-cut shading screen patterns. Thaves also relies on his computer to deliver all strips to his syndicate by modem, taking a mere eight minutes to transmit and deliver a week's worth of material just before deadline. Keeping the original art in his studio allows Thaves to archive and store copies of his cartoons on disk for later use in promotional materials and licensed products such as greeting cards and T-shirts. Readers and fans of *Frank and Ernest* communicate with Thaves every day, using the e-mail address which appears on each strip. In the future, as a new generation of computer-friendly cartoonists comes of age, Bob Thaves predicts that technology will play an increasingly greater role in both the creation and business of professional cartooning.

draw almost anything with greater detail and authenticity. If you need to draw a knight in armor, for example, or a monster truck or a racing bike or high-fashion clothing or a castle, photos of these items could help you to get the details right and draw them better. Even though a cartoonist does not draw realistically, specific details of an item will help your reader understand what it is you've drawn. Details, for instance, would help you draw a motorcycle that your audience won't mistake for a bicycle.

One of the best reference books you can get is a mail-order catalog from a large department store chain. These books have toys, athletic

equipment, office equipment, clothing, shoes, underwear, camping gear and much more. A well-illustrated encyclopedia is another excellent reference, including those now available on CD-ROM. Other reference CD-ROMs can be found in any computer store or catalog and feature nothing but animal photos, sports photos, celebrities and other specific photo categories which you can use for reference. You may also want to begin using a reference file cabinet, stuffing it full of magazine and newspaper clippings organized by category.

You never know what you'll be asked to draw next, so a good reference library can help you become a great cartoonist.

I have a spare bedroom in my home that I would like to turn into a studio. What furnishings and equipment do you recommend for a good cartooning studio?

On the most basic level, you really don't need anything fancier than a table, a chair and a lamp. If you have a few dollars to invest in something more professional, here are a few suggestions.

1. Get a sturdy drawing board or drafting table. A good drawing board will give you plenty of work space and can be adjusted to different angles to make you as comfortable as possible as you draw. Some drawing boards are made from wood or particle board, others are metal; any of these will work just fine. Fairly inexpensive drawing boards can be found in many department stores or can be obtained from an art supply store. Some catalogs sell very large and expensive drawing boards, but they won't make you draw any better than a smaller, less expensive model. You'll also need a comfortable chair to sit on, one with wheels to allow freedom of movement around your drawing board.

2. Buy a desk lamp to mount on your drawing board. It should have an adjustable arm to put the light where you need it most and should be bright enough to prevent eye fatigue and strain. Many professional-style lamps are available through art supply catalogs and stores.

3. You'll also need: a ruler; a paper cutter or scissors or a sharp knife for cutting paper and illustration board; a drafting T-square and triangle for layouts; a pencil sharpener; and a variety of miscellaneous items that you'll discover as you thumb through your supply catalogs.

4. A stereo, radio or television is always good to have in your studio to help you pass the time as you draw. A television by your drawing board makes it much easier to spend time in your studio instead of in your den. (Many cartooning careers probably never got off the ground because the

After her break-up with Larry, Christie set a new school record for pouting, with a bottom lip measuring a full 24.5 inches.

Cartoonist Profile:
BUD GRACE

Ernie, by Bud Grace, has attracted a devoted and enthusiastic following since it was launched by King Features Syndicate in the late 1980s. Bud has become one of the most popular comic strip cartoonists in the United States, despite the fact that he was trained to be a physicist and did not begin drawing cartoons until he was well into his thirties. "I had no big break," Bud reveals. "It took me eight months to sell my first gag cartoon to *Saturday Review*. As time went by I sold more and more to other magazines. Seven years later, when I felt I was good enough, I dropped *Ernie* off at King Features and they bought it."

Bud's art influences include underground artists Robert Crumb and Kim Deitch as well as legendary cartoonists Elsie Segar, Billy De-Beck, George Herriman, and B. Kliban. "I never tried to copy a style," Grace explains, "but I tried to pick up on techniques. The humor is pretty much my own. I draw what *I* think is funny.

"Breaking onto a comics page with my underground-influenced style of humor is still pretty rough. But once I build a fan base, they're pretty loyal. A lot of people don't understand my work. It's not the simple, basic gag humor that everyone else does. For that reason, it's hard to build a broad fan base. My fans are specialized, I think.

"To get my ideas, I go out for a long two-hour walk and I think. It's very difficult for me to just sit down and write a gag without that movement. I've always done it this way, I've always walked. It's a habit now. Plus it gives me some exercise, which is good for someone who sits at the drawing board much of the day. I don't bring a tape recorder on my walks—I'm usually able to remember my ideas when I get home. If I had a formula for writing, it would be easy. It's not."

To succeed in cartooning, Bud Grace believes aspiring cartoonists should draw as much as possible and try to get published anywhere they can. "The best way to improve is by seeing your work in print. You have to be totally dedicated, pig-headed. It takes both talent and fortitude to make it in this business. You must work very hard and never give up. I went eight months without income before my first sale!"

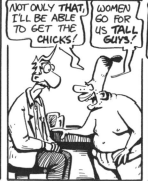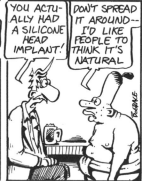

With special permission of King Features Syndicate.

cartoonist never got off the couch!) If a television causes you to look away from your drawing too often, darken the screen and listen to your television as if it were a radio. For artists who enjoy reading, a tape player is a great way to "read" an audio book while you're drawing.

5. When the weather is warm, be sure to invest in an air conditioner for your studio if at all possible. This will make you much more comfortable while you draw, plus it will prevent sweaty forearms from sticking to your paper and will keep perspiration from smearing your work. Of course, if you've got a pressing deadline or are having trouble coming up with a funny idea, you may break into a sweat no matter how cool your studio is!

6. Once you've reached a professional level, you will probably need to add a telephone to your studio, or better yet a fax with a built-in phone and answering machine. You might also consider buying some sort of personal computer and printer for typing cartoon captions, recordkeeping and general business accounting and correspondence. An electric typewriter will serve you well, but a personal computer is more versatile and will be far more useful overall. Most professionals also find it very helpful to keep a photocopier in their studio, rather than having to travel somewhere else to have copies made. At the professional level, you will also need a stock of common business supplies (a file cabinet, bulletin boards, rolls of tape, paper clips, thumbtacks, glue, stapler, trash cans, book shelves, and so on).

With plenty of hard work, drive and persistence you may outgrow your spare-bedroom studio someday and be able to build a whole new studio complex big enough for you, your secretary, business manager, assistants and a fanatical flock of cartooning groupies!

Do professional cartoonists usually rent space for a studio, do they share a studio with other cartoonists, or do they usually just stay in the same corner of the den where they first got started**?**

Every cartoonist's studio is different. Tom Cheney draws his cartoons for *Mad* and *The New Yorker* in a large room of his house that was originally designed to be an apartment for in-laws. The late Dik Browne created *Hagar The Horrible* in a laundry-strewn basement studio under his home. For many years, Mort Walker and his staff produced *Beetle Bailey* in a studio located over his family's garage. Johnny Hart now draws *B.C.* from an attractive studio built especially for his creative enterprises, but years ago he reportedly created his cartoons in a rented studio located above a tavern. Just after the publication of Lynn Johnston's first book (prior to her tremendous success with *For Better or For Worse*), she converted an abandoned greenhouse into a studio for freeiancing. *Mad* magazine cartoonist John Caldwell likes getting out of the house and going to work every day, so he freelances from a rented studio that had once been the office of a dental supply company (they left behind a dentist's chair which is now part of Caldwell's official cartoonist furniture). My own syndicated panel, *The Better Half,* is created in a large, three-room studio located

GLASBERGEN

Danny decided to clean up his lifestyle after his shadow refused to be seen with him.

on the third floor of my big, old, creaky Victorian home which had been a boarding house many years ago. Most cartoonists confess that their studios are a cluttered combination of half-finished projects and half-finished doughnuts, with janitorial skills usually receiving far less priority than artistic skills.

You may prefer to rent a studio if the distractions of family life interfere with your creative bliss, or you may find that you are more comfortable having a studio at home, surrounded by the companionship of family, pets and the ever-beckoning fridge. Working from home is also a great way to economize, saving hundreds of dollars on studio rent each month.

You should work in whatever area is most comfortable, practical and productive for you. For many cartoonists, the ideal location might be at a drawing board on staff at Hallmark Cards, Disney Studios, or American Greetings, miles away from home and the precarious nature of freelance life.

When you're ready to chase your own personal cartooning dreams, you'll surely find the location that is right for you.

Developing Great Style and Characters

No matter how much I practice, my cartoons still look kind of crude and amateurish. My characters don't look very exciting either. How can I make my characters look like real, professional-quality cartoons❓

Great cartoon characters and a professional style can be yours with practice. Although all great cartoonists are born with some degree of natural talent, nobody is born great. Natural talent, all by itself, is pretty useless. It takes talent and practice plus plenty of drive to become a great cartoonist. When you look through this book, keep in mind that every cartoonist on these pages started out as an untrained, unprofessional, unsuccessful, goofy little runny-nosed kid who loved to draw cartoons. If your favorite cartoonists could transform their natural raw talent into professional-quality work, you probably can too . . . if you try!

Here are some tips to help you create a more professional cartooning style.

1. *Study the work of the cartoonists you enjoy and admire.* Pay close attention to the details of their work. When you're reading *Calvin & Hobbes*, pay attention to how short Calvin's legs are compared to the length of his torso then try that sort of thing with the legs on your own characters. When you see a *Ziggy* cartoon, notice how much the shape of his body resembles the shape of a water balloon, then pretend your own characters'

bodies are made from water balloons and see what happens to your style. When you see the enormous noses that Rick Kirkman draws in *Baby Blues*, try creating some huge honkers of your own. Click on your television and watch *Ren & Stimpy* with a sketchbook on your lap and try imitating some of the outrageous and grotesque eyes, mouths, and bodies you see on the screen. If you're attracted to the lovable scruffiness of *Frank and Ernest* try adding some lovable scruffiness to your own characters. Whatever you see and enjoy in your favorite cartoons can be adapted to your own evolving personal style.

Don't copy other people's work, but do feel free to borrow bits and pieces for your own characters. Learn to think of yourself as a Dr. Frankenstein, creating a new life from bits and pieces of other bodies! Don't feel guilty about doing this, because the people you're borrowing from probably borrowed bits of their characters from the cartoons they admired! Once you borrow an ingredient, however, be sure to make it your own—change it somehow to create something similar but new. *Imitation + innovation = style.*

2. *Get into the habit of doodling.* Don't substitute doodles for your regular cartoons, but do take time now and then to doodle as a form of playful practice. Doodling is a great way to break free from your usual drawing habits and accidentally discover something new and exciting to add to the unique look of your characters. If you

To discover a new trick, break out of a rut, or explore a new style or technique, nothing is better than doodling! Doodling allows wonderful accidents to happen. Make doodling a regular habit and watch your drawings improve faster than ever!

normally draw characters with large, grotesque noses, a doodle may accidentally show you how interesting your characters look with tiny noses instead. An hour spent doodling may help you discover an exciting new hair shape for your characters or a quirky new posture or a wild new jaw formation or a great new way to make interesting faces. Doodles are full of surprises!

When you're doodling, remember to let go of all restrictions. For doodling, the only rule to remember is "No rules!" Anything goes! Break the connection between your judgmental mind and your hand. Let your hand do whatever it wants to do on the page. If your hand wants to scribble, let it scribble. If your hand wants to put eyeballs at the end of a nose, let it. If your hand wants to draw everything in sharp, angular lines, that's fine. If your hand wants to put down the pencil and pick up the TV remote control, that's not good; otherwise, try to allow your doodling to be as free and unrestricted as possible.

If you discover something exciting in your doodles, try incorporating it into your style. For example, if one of your doodles was a man with his eyeballs very far apart and you like the way it looked, then use that ingredient in your next cartoon. If you've created a doodle with an exciting new element in it, tape that doodle up on your drawing table so you won't forget it. Make doodling a lifelong habit. Never stop doodling and never stop growing.

3. *Find a way to make your characters look distinctive.* Perhaps the most distinctive and memorable cartoon character of all time is Popeye—nobody else looks quite like him, with his freakish, keg-sized, tattooed forearms; a jaw that looks like two cantaloupes glued together; one bulging eye and one eye socket sealed shut; thick lips and mouth dislocated to one side of his face; a brightly colored sailor suit; an addiction to the miraculous powers of canned spinach; and a corncob pipe that goes "poop-poop" when he blows into it! If you can create characters as distinctive as this, you'll have no trouble capturing the attention of your readers.

If your characters look bland and uninteresting, look for ways to make their appearance more memorable. For example, when you think of Charlie Brown, you quickly get a mental image of a kid with an enormous round head and a zigzag on his sweater. Charlie Brown looks like nobody else on the comics page. Hagar the Horrible is a memorable character because of his big mouth, huge hairy tunic and Viking horns. Charles Addams' macabre cartoons in *The New Yorker* inspired *The Addams Family* of TV and movie fame with its

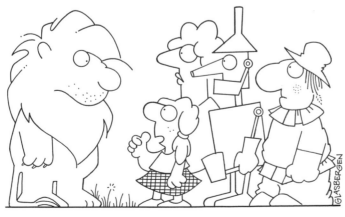

"The scarecrow wants a brain, the Tin Man wants a heart, and Mrs. Jones wants a new nose."

Cartoonist Profile:
TOM WILSON

With virtually no more human characteristics than a water balloon, Tom Wilson's *Ziggy* is one of the most identifiable cartoon characters ever created. It seems as though his image has decorated more greeting cards and calendars than any other cartoon character in history, and his newspaper comics have been a great success for more than twenty years.

"I believe I was influenced more by Laurel and Hardy than other cartoonists," explains Wilson. "My drawing style evolved over the years, although Ziggy I more intentionally developed to establish his ongoing personality and lifestyle."

Getting ideas is a challenge for every great cartoonist, and Tom Wilson is no exception. "Usually I will have a scribbled line, a few notes on some scraps of paper, but sometimes I run an exercise of drawing Ziggy in a situation without knowing where it's going—it's scary, but Ziggy's personality and his point of view invariably pull me though. Ziggy himself helps me a great deal. I really like him and I've never gotten bored working with him."

Wilson offers this advice for beginning cartoonists: "Do not try to emulate existing styles or ideas. Try to bring something unique and personal to the field that wasn't there before. And I wish everybody the best of luck in their efforts. Humor in any form is such a positive way to earn a living."

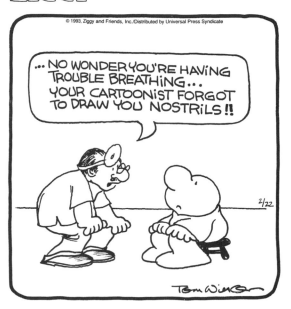

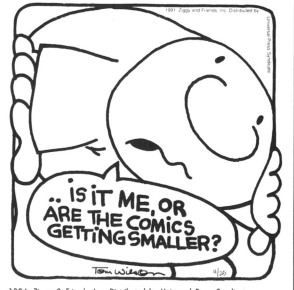

1994, Ziggy & Friends, Inc. Distributed by Universal Press Syndicate.

cast of distinctive and memorable characters, including Gomez, Morticia, Cousin It and Pugsly. The comic strips *Luann*, *Funky Winkerbean*, *Archie* and *Fox Trot* are all about teenagers, yet the look of each strip and cast of characters is distinctive and completely different from the others—there's very little chance of confusing one for another.

Take several minutes to think about famous characters from comics, movies and television. Try to identify what unique visual elements have made them so easy to recognize and remember: Garfield, Bill the Cat, Dagwood, Nancy, Zippy, Beetle Bailey, Sergeant Snorkel, Broom Hilda, Irwin the Troll, The Wizard of Id, Olive Oyl, Betty Boop, Bart Simpson, Ren and Stimpy, Mickey Mouse, the Marx Brothers, the Three Stooges, the Coneheads and *Seinfeld*'s Kramer.

With the previous examples in mind, find a way to make your characters look memorable and unique. This book can't tell you how to do that. You have to figure that out your-

self, just as every great cartoonist has done. For starters, just get playful and try all sorts of weird gimmicks. Create a character whose body is shaped like a large turkey drumstick or a character who resembles a marshmallow on a severe August afternoon or make your cartoon character's eyeballs larger than the rest of his head. Try thin characters and fat characters, very tall and very short characters. Human characters who resemble animals and animal characters who resemble humans. Experiment with different geometric shapes—with bodies and faces shaped like rectangles, ovals, circles, triangles or pears. Try different costumes, props and hairstyles on your characters. The more time you spend drawing and experimenting, the more opportunities you'll have to discover what's special about you and your personal style.

 have trouble giving my cartoon characters the right facial expressions. When I try to draw a

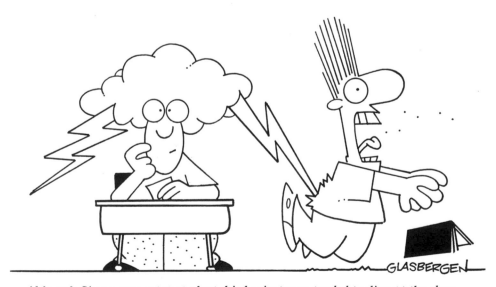

Although Simon was a top student, his brainstorms tended to disrupt the class.

sad face, it looks angry. When I try to draw a happy face, it looks excited. I never seem to get just the right look. What am I doing wrong**?**

You're not doing anything wrong. You're learning and there's nothing wrong with that!

Here's a suggestion: When you're trying to draw a particular facial expression, use a mirror to study your own face. Remember, most of the time you'll be alone at the drawing board, so don't depend on friends and relatives to pose for you. Make a sad face in the mirror and pay close attention to the position and shape of your eyes, eyebrows, mouth, neck and shoulders. Now make an angry face in the mirror and watch how your face changes. Try drawing both and you'll see the differences. If you're not very good at acting out faces, find different expressions in magazine photos, identify the emotion in each photo, and practice drawing it. The same methods can be used for other drawing challenges, such as body shapes, body parts, body language and various action movements (walking, running, sitting, golfing, pouting, resting and so on). With plenty of practice and attention to detail, you should see quite a bit of improvement in your work.

My cartoon characters all look pretty interesting, but I can't think of anything interesting or funny for them to do. How can I give my characters funny personalities**?**

The best cartoon characters have vivid, memorable and predictable

GLASBERGEN

character traits. Every truly great cartoon character has his own peculiar personality quirks which determine how he responds in any situation. For example, Beetle Bailey on a farm is going to behave quite differently from Dennis the Menace on a farm. Likewise, Marmaduke in a veterinarian's office will behave very differently from Garfield in a veterinarian's office. It's not the farm or the vet's office that makes these characters funny, it's their distinctive personalities that cause us to laugh at them year after year. Snoopy has an ego and imagination that would make him funny in any situation—in a shopping mall, on a school bus, when he's hungry, when he's full, when he's in love, when he's depressed or when he's angry. Conversely, Mike Peters' Grimmy the dog is more manic and mischievous than Snoopy, so he would behave quite differently in a shopping mall, on a school bus, when he's hungry, when he's full, when he's in love, when he's depressed and when he's angry—and his unique personality would also make him funny in any situation.

One of the best ways to draw expressive cartoon faces is to study your own face in a mirror. Pay attention to how different expressions affect the position of your eyebrows, the size of your eyes, the flare of your nostrils, the position of your neck and shoulders, and the shape and positioning of your mouth. Expressive faces may be the most important key to creating great cartoon characters.

Unless your cartoons are somewhat true-to-life like the family in Lynn Johnston's *For Better or For Worse*, your characters may need to display some larger-than-life quirks, attitudes and behaviors to make them special and interesting. These traits should affect everything your characters say and do, as well as how they interact with all of your other characters (each of whom has their own larger-than-life traits). Great characters have great personalities that create great humor almost automatically in any situation. Great cartoon characters say and do funny things—they don't just stand still watching funny things happen around them.

Here's a little experiment you can try. Suppose one of your characters is a tall, wiry, worrisome, nervous wreck who has a habit of drinking way too much coffee. How would he respond in the following situations? On a crowded subway car in July . . . shopping for a new car with his demanding, perfectionist wife . . . taking the dog to get neutered . . . getting audited in an IRS office . . . ordering breakfast in a crummy diner . . . learning how to use a personal computer . . . cleaning a cat's litter box . . . visiting a marriage counselor for the first time . . . going to his boss's funeral. With a little imagination and a small bit of effort, it's very easy to predict how this character would behave in each scenario. That's the magic of classic cartoon characters and their funny personalities that stay interesting and amusing year after year, decade after decade!

To learn more about creating characters, read *Creating Characters, How to Build Story People* by Dwight V. Swain (Writer's Digest Books). While this is not a book about cartooning, its methods for inventing fully developed and believable characters should help you with your own comic characters.

As both an aspiring cartoonist and a great cartoon fan, I read and study cartoons all the time. It's easy to study the work of contemporary cartoonists, but who are the great cartoonists of the past that are worth studying?

Just as a contemporary musician should study great musicians and composers from the past, a modern cartoonist should pay attention to the great cartoonists and humorists of the past. A library is the best place to start looking for old cartoon collections or historical books on cartooning. One book you should look for is *The Great American Comic Strip, One Hundred Years of Cartoon Art* by Judith O'Sullivan (Bulfinch Press Books, Little Brown and Company). Your local comic book shop is also a great place to find recent books containing the collected works of Al Capp, Ernie Bushmiller and many other classic cartoonists from the past. You should also search libraries and flea markets for old, out of print cartoon collections by classic cartoonists.

Some great comic strip artists of the past who have influenced today's great cartoonists are Carl Anderson (*Henry*), Walter Berndt (*Smitty*), Dik Browne (*Hagar the Horrible*), Ernie Bushmiller (*Nancy*), Al Capp (*Lil Abner*), Percy Crosby (*Skippy*), Billy De Beck (*Barney Google*), Rudolph

Cartoonist Profile:
TOM K. RYAN

Tumbleweeds, by Tom K. Ryan, has one of the largest casts of characters of any strip around. The many characters in this long-running Western strip have unique and distinctive personalities and represent the many stereotypes we all encounter. The ensemble includes: Tumbleweeds, a lackluster cowpoke trapped in a lackluster life; Hildegard Hamhocker, a passionate, desperate husband hunter; Judge Horatio Curmudgeon Frump, the local crooked politician; Snake-Eye and Snookie McFoul, the local bad guys; and Deputy Knuckles, the stupidest stupid guy in the funnies. Each character has been created to behave according to his or her own wacky, yet identifiable, stereotype.

For cartooning, Ryan recommends a broad, general education with some specialization in art. "I held down various jobs after I married, to support a growing family, while doing some local newspaper editorial and sports cartoon work. I landed a job at the bottom of the commercial art ladder and gained a working ability in all phases of that field by on-the-job experience. Later I took a correspondence course in commercial art which gave me many of the basics I had neglected earlier in my education. Through my commercial art experience, I became proficient in a number of art and cartooning styles. I developed a particular style for

Tumbleweeds and was initially influenced by Johnny Hart's graphic approach in his *B.C.* strip, which was a new strip at the time.

"Producing a strip is demanding work and takes everything I have every working day. The excitement comes from discovering what funny ideas I can produce, seeing the strip in print and knowing that others will get a laugh from it. It's a thrill having your strip published nationally for the first time. That you'll always remember. But the honeymoon soon ends and the daily maintenance of it and the job of gaining an audience soon becomes the bottom line. Syndication is particularly demanding these days because of the very limited space for which a growing number of features are constantly vying."

After years of syndication, the *Tumbleweeds* characters are finding even greater success in the business of character licensing and merchandising. Ryan's characters are a popular attraction at the MGM Grand family theme park in Las Vegas, Nevada, where they mingle with visitors and are featured in shops and novelties. Many other projects are being discussed to capitalize on the enduring popularity of Ryan's unique and memorable characters, promising the same kind of success enjoyed by other popular characters such as Snoopy, Garfield, Betty Boop and Popeye.

Dirks (*The Katzenjammer Kids*), Bud Fisher (*Mutt & Jeff*), Chester Gould (*Dick Tracy*), Harold Gray (*Little Orphan Annie*), Milt Gross (*Nize Baby*), Jimmy Hatlo (*They'll Do It Every Time*), George Herriman (*Krazy Kat*), Bill Hoest (*The Lockhorns*), Walt Kelly (*Pogo*), Windsor McCay (*Little Nemo*), George McManus (*Bringing Up Father*), Frederick Opper (*Happy Hooligan*), Elzie Segar and Bud Sagendorf (*Popeye*), R.F. Outcault (*The Yellow Kid*), Otto Soglow (*The Little King*), Cliff Sterrett (*Polly and Her Pals*), Pat Sullivan (*Felix the Cat*), and Chic Young (*Blondie*).

There are also many wonderful magazine and editorial cartoonists of the past from whom you can learn: Peter Arno, George Price, James Thurber, John Held Jr., Thomas Nast, Rea Irvin, Charles Dana Gibson, Art Young, A.B. Frost, T.S. Sullivant, Ralph Barton, Gluyas Williams, Russell Patterson, Rube Goldberg, Richard Taylor, Gardner Rea, E. Simms Campbell, Ed Nofziger, Jack Markow, Charles Addams, Sam Cobean, Abner Dean, Al Kaufman, Virgil (Vip)

Partch, Harvey Kurtzman and B. Kliban, among others.

By studying the work of a variety of cartoonists, past and present, you open yourself up to be influenced by an enormous range of styles and techniques. You're also less likely to be overly-influenced by any one cartoonist and less apt to see your style become too similar to someone else's work. Try to remember or recognize the names of the great cartoonists of the past and look for samples of their work whenever you can. Remember, at one time their work was just as popular and influential as *Calvin and Hobbes*, *Peanuts* or *The Far Side* are today. Their work is valuable and is well worth remembering.

If you'd like to see original comic art from the past, the actual pen and ink artwork of the classics, try to visit The International Museum Of Car-

"You can't execute my client, Your Honor—he hasn't paid me yet!"

toon Art and The Cartoon Hall of Fame. This world class museum, founded by Mort Walker, was originally located in Rye, New York, and has since expanded and relocated to southern Florida where it is becoming a major tourist attraction and educational resource.

I 've always loved all kinds of cartoons—comic strips, magazine cartoons, greeting cards and animated TV cartoons. I notice that some cartoons are very well drawn and others look sort of poorly drawn and downright ugly. Why should I practice and practice to draw better when so many terrible, amateurish cartoons are getting published**?**

Just as many people disagree about what qualifies as good music or good food or good paintings, many people disagree on what is or is not a good cartoon. Diversity helps keeps cartooning lively and interesting. A record shop that only sells classical recordings is a lot less interesting than a record shop that sells classical, jazz, pop, rock, rap, dance, heavy metal, show tunes, children's music and comedy albums. Likewise, a newspaper that publishes many different types of cartoons will appeal to more people than a newspaper that only runs the editor's personal favorites.

A cartoon style is more than just drawing. Style is also an *attitude*. An unconventional or rebellious attitude is best expressed with unconventional or rebellious artwork, some of which may appear to be sloppy or amateurish. If a cartoonist is rebelling against cute and adorable or blatantly commercial cartoons with little creative integrity, then his style is likely to be anything but cute and adorable. It might help to compare this style of cartooning to punk or grunge rock music. The drawing style of any great cartoon should be well matched to its attitude and point of view. It would be impossible, for example, to represent the creepy, adolescent attitudes of *Beavis and Butthead* with a pleasant, attractive style resembling Bil Keane's *Family Circus* or George Gately's *Heathcliff.*

Actually, many of the amateurish-looking cartoons and greeting cards being published are not done by amateurs at all. Those loose, freewheeling styles are the creations of talented and skilled artists who are working very hard to achieve a particular look for their designs. As different styles of music communicate different moods and emotions to the listener, different cartooning styles communicate different moods and emotions to the reader. A loose, funky drawing style with sloppy color communicates a light, free-spirited mood to the reader—an unskilled amateur probably could not convey that mood as effectively.

Great cartoons come in many different styles. Your style should reflect who *you* are. You can waste years chasing the latest trendy style and never discover your own unique method of self-expression. Study everyone else's work and allow yourself to be influenced by other styles, but don't lose sight of your own place in the world. Your cartoons may be crisp and clean or loose and freewheeling, but most of all they should be *you!*

Cartoonist Profile:
BIL KEANE

Most great comic strip characters are created at a drawing board in a studio. Bil Keane created the kids from *The Family Circus* in more intimate surroundings. Keane's characters Billy, Dolly, Jeffy and PJ were all modeled after his own real-life offspring Gayle, Neal, Glen, Chris and Jeff.

"Most of my ideas are based on things that happened in our own family. Many times I will simply take a typical family situation, put myself in the place of Billy, Dolly, Jeffy or PJ, and draw a scene that depicts how I would act or what I might say. To keep the cartoons fresh and modern, I thumb through family, parent and baby magazines. These days a volume of mail from readers brings in many suggestions from their own lives, some of which are usable. Now that our children are grown I follow eight small grandchildren around for ideas. While a cartoon thirty years ago might have shown a child playing with Tinkertoys, today the kid is shown playing Nintendo."

Before Keane found success with *The Family Circus*, he had a solid foundation of freelancing behind him. "Age was definitely a plus in my case. When I started *The Family Circus* I was thirty-eight years old and had already worked as a staff artist for the *Philadelphia Bulletin* for

THE FAMILY CIRCUS® **By Bil Keane**

10-3
©1989 Bil Keane, Inc.
Dist. by Cowles Synd., Inc.

You can't have the TWO best jobs on the paper, Billy! Which one do y'want—Editor or Cartoonist?"

fifteen years, had drawn freelance cartoons for major magazines, and was already doing *Channel Chuckles*, a syndicated panel about TV." When big-time success came, Keane was clearly prepared. "I was not surprised by my success. I made it happen, I didn't just fall into it. Part of being successful is being confident in yourself. You need some degree of healthy egotism. Luck may play some role, but I've always had a tremendous amount of drive and persistence. I was always very passionate and driven to get into print. *The Family Circus* started in 1960 in 19 newspapers and we're now in well over 1400 papers worldwide."

From his perspective at the top of his field, Bil Keane has some words of caution for newcomers. "To be a great cartoonist, you need originality. You have to stand out from the crowd. But I think new cartoonists are trying too hard to be different. They're not true to what they do best. The stuff often seems calculated and forced. Draw cartoons on the subject you know best. Don't try to fake it. Be yourself. Sincerity is important if readers are going to relate to your work. Have confidence in what you're doing. Listen to criticism, but weigh it. Be prepared for rejection, but do not give up. There is no one exactly like you. Remember that."

THE FAMILY CIRCUS® By Bil Keane

2-25
©1994 Bil Keane, Inc.
Dist. by Cowles Synd., Inc.

"Our Father, who art in heaven, how did You know my name?" The Family Circus © 1994 Bil Keane, Inc.

Can the tools I use influence or inhibit the development of my personal cartooning style? Will using the wrong tools hurt my style❓

Yes, the pens, brushes and paper you draw with can affect the way your style develops. If you're in the habit of inking cartoons with a Hunt #102 pen and then you switch to a red sable brush, it's going to change the look of your work. Or if you're used to the flowing lines and three-dimensional quality of a brush, changing to a Flair pen is going to make all of your pen lines much thinner, crisper and more uniform in size. On the other hand, a Flair felt-tip pen will give you the free-dom to sketch rapidly in a way that is not possible with most pen points or a brush, which may require more controlled hand movements.

To discover the style that's right for you, you really must experiment with a variety of tools while your style is evolving. Changing from a pen to a brush could completely revolutionize your style and give your work a look that you never imagined possible! Adding gray halftone wash (with gray markers or diluted black water-color paint) could make your work look more complex or sophisticated than before. If you've been uncom-fortable and awkward using a metal pen point dipped in India ink, switch-ing to a felt-tip pen could liberate your

After three months as a camp counselor, Brian gained twelve pounds—
one pound of muscle and eleven pounds of bug bites.

Cartoonist Profile:
RUSSELL MYERS

Broom-Hilda, by Russell Myers, is one of the most popular fantasy strips ever created. Broom-Hilda the witch, Gaylord the buzzard and Irwin the troll have been entertaining readers since the early 1970s. Some may remember *Broom-Hilda's* cartoons on television; others may recall washing up in Broom-Hilda bubble bath. Twenty years later, *Broom-Hilda* and Russell Myers are still going strong.

"I grew up in Oklahoma," Myers recalls, "and never saw another cartoonist until I was in my twenties. I took art courses all through high school, but am really self-taught. I spent my paper route money on comic books and newspapers and studied everybody. Then I sat down and drew and drew and drew. Another great influence was the Jack Benny radio show. I was a rabid fan of what was really wild humor for the day. I have over three hundred old Benny shows on tape and they still make me laugh."

While struggling to achieve fame as a cartoonist, Myers was employed as an artist and writer for Hallmark Cards. "I tried a half dozen strips during my tenure in the greeting card racket and they all failed. Finally, as I was poised to tiptoe off the edge of the roof of the Hallmark building, the Success Fairy lighted upon my shoulder. Well, not exactly. A friend of mine ran into a successful comic writer in New York, Elliott Caplin (brother of Al Capp). Elliott wrote *Juliet Jones*, *Big Ben Bolt*, *Abbie and Slats* and others. He had an idea for a humor strip about a witch named Broom-Hilda, but he wasn't a humorist. I did samples, and he sold it. We've been partners ever since. I write and draw the strip and he handles the business end. It's that old story of being an overnight success after you've prepared for it for fifteen years."

"To get the creaky, old creative juices flowing, I frequently read the funny pages. Reading cartoons gets me in the 'cartoon think mode.' Then I search through magazines and my memory of recent events for subject material. For me the hardest part is not writing a joke, but coming up with the subject about which to write."

"All men are *not* created equal," Myers believes. "You can't force greatness onto yourself. Greatness is an intangible sort of genius—some people are born with it, it's a gift. It's tough to succeed in this business. You have to love what you do and be willing to work like a dog and be kicked in the head by failure sometimes. Sometimes it's the ones who are too stubborn to quit that go all the way."

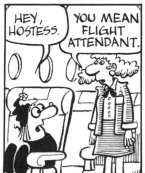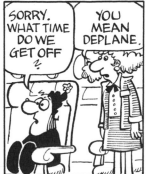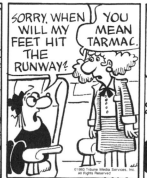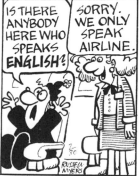

hands and let your true style emerge.

As you become more successful as a cartoonist, you will build your reputation and career around a particular style, so changing your tools and style at that point could be a risky career move. The early part of your cartooning career is the best time for you to experiment wildly and enjoy your freedom. Don't make the mistake of getting locked into a particular style too soon.

Once I drew a funny comic strip about a space explorer and his copilot, a talking sheep. I thought it was pretty outrageous and original, but the syndicates all said it was too contrived and unbelievable. How am I supposed to create fresh and original characters if the editors insist on comic strip characters that are just like ordinary real people?

The best comic strip characters are ones many readers can relate to. It's much easier for readers to identify with a talking person than a talking toaster, for example, because most of us have very little in common with talking toasters.

Fantasy characters can be very successful, but readers must be able to identify with their circumstances and personalities. The strip *Broom-Hilda* by Russell Myers is a great example of a fantasy strip with true-to-life characters: Broom-Hilda the witch doesn't take any flack from anyone, her no holds barred aggressiveness is a trait many readers envy; Gaylord the buzzard is the antithesis of Broom-Hilda, an intrusive and meddling advisor who talks too much and acts too

little; and Irwin the Troll represents the joyful, carefree, childlike innocence we wish we could have held on to long after infancy. Throughout literature, fantasy characters of all sorts, from works as diverse as *King Arthur*, *The Wizard of Oz* and *Star Wars*, have captivated audiences by presenting honest emotions and real life experiences in bright, colorful disguises. Most of us all over the world share many of the same basic, primal emotions and relationships. Fantasy characters, fairy tales and fables are simply an exciting and interesting way to explore and express those feelings and experiences we all have in common. So go ahead and create wonderful imaginative characters, but be sure your characters and stories are all based on things readers can identify with and care about.

What's the difference between creating characters for magazine cartoons, creating characters for greeting cards and creating characters for comic strips?

Magazine cartoons, greeting cards and comic strips all feature fun cartoon characters, but each format requires a different type of character to be effective.

Magazine cartoon characters are generally simple stereotypes. Readers have no ongoing relationship with those characters, so we don't need to know much about them. In a magazine cartoon, it is usually sufficient to know that the character is a lawyer, a doctor, a mother, a king, an executive, a florist, a dog or whatever. To be a great magazine cartoonist, you

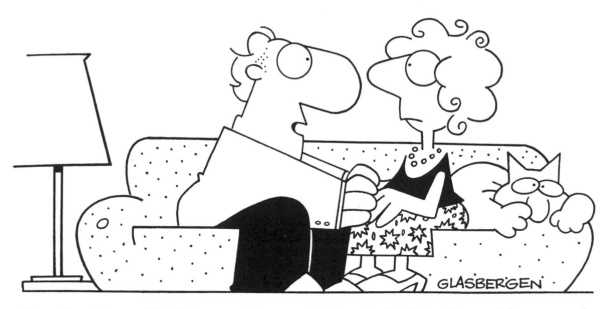

"Commitment is very difficult for me, so let me ease into it gradually. Today I'll commit for one second, tomorrow I'll commit for two seconds, the next day I'll commit for three seconds. . . ."

must be able to skillfully convey different character types instantly, so the reader can identify your characters at a glance before reading your caption for a quick laugh.

In years past, many magazine cartoons featured recurring characters such as *The Addams Family* (by Charles Addams) in *The New Yorker*, *Hazel* (by Ted Key) in *The Saturday Evening Post*, and *Brother Sebastian* (by Chon Day) in *Look* magazine. Today, this sort of feature is very uncommon, but a few recent examples, such as *Howard Huge* (by Bunny Hoest and John Reiner) in *Parade Magazine* and *Bad Baby* (by Patrick McDonnell) in *Parents Magazine*, have continued the trend. Aside from these rare exceptions, magazine cartoons do not feature recurring characters. In magazine cartoons, every character role is a cameo.

Greeting card characters are different from both magazine and comic strip characters. Greeting card charac-

Unlike any character from a long-running comic strip or feature-length animated film, a magazine cartoon character has a very brief encounter with its reader. A magazine cartoon is usually just a fun little surprise in the back of a magazine, to be read quickly and forgotten soon after the next page is turned. Even if a magazine cartoon is great enough to warrant a spot on your refrigerator door, you don't need to know much about the characters. A magazine gag captures one brief humorous moment in time—the reader has no need to know what happened before or after that funny moment.

ters are created to be decorative, attract the consumer's attention, and indirectly represent the identity of the buyer/sender. The character on a card's cover speaks for the person sending the card. For example, a friendship card complaining about how dreadful men can be is likely to have a picture of a disgruntled young woman on the cover because the card is meant for disgruntled young women to send to other disgruntled young women.

A greeting card is a very personal message created to appeal to as many buyers as possible, so it is impossible to directly represent the exact look and personality of every buyer

Cartoonist Profile:
BILL GRIFFITH

There are dozens and dozens of cute, lovable cartoon characters in the newspaper. And then there's *Zippy the Pinhead* by Bill Griffith. *Zippy* was originally created for the underground comics of San Francisco in 1970 and was partly inspired by a 1932 film, *Freaks*. (Zippy, Griffith claims, is named after William H. Jackson, a real-life Barnum and Bailey circus attraction who was born in 1842 and exhibited as "Zip the What-Is-It?" from 1864 until 1926.) In 1986, *Zippy* moved above-ground and is now successfully syndicated to newspapers by King Features Syndicate.

The humor of *Zippy the Pinhead* is different from most mainstream comic strips and so the strip is often referred to as a cult favorite. "I care whether or not someone 'gets' *Zippy*," explains Griffith. "I just don't hand over the whole thing on a platter. I ask the reader to work a little and meet me half way. Sometimes a reader will tell me that he had to read a *Zippy* strip three or four times before he 'got' it. That makes me happy. I don't do comics so they'll be forgotten a few minutes after being read. I figure plenty of cartoonists are working the 'joke' medium. I try to do something entirely different and hope there's an audience out there for it. I'm satisfied with a cult following, although I would have no objection to it becoming larger over the years.

"I had no specific training in cartooning, per

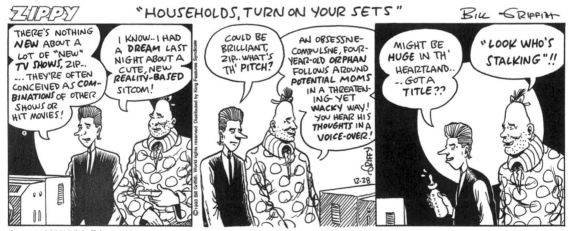

Zippy © 1993 Bill Griffith.

se, but I was exposed to several professionals during my childhood, growing up in Levittown, New York. My mother was Lawrence Lariar's secretary. He was a gag cartoonist and mystery writer. Every year he put together a hard-cover anthology called *Best Cartoons of the Year*. My mother would bring home hundreds of original drawings by the major (and minor) gag cartoonists of the time and we'd pick our favorites for the book. (This was one of many such projects, so Lariar was glad for the help.) I also lived next door to sci-fi illustrator Ed Emshwiller and he became something of a role model. He used me and my family as models for his paintings. I was very impressed that he worked at home and didn't have to commute. Of course the major influence on my budding cartoonist career was *Mad* magazine (especially the Kurtzman years) and *Humbug*, my favorite reading material.

"My career moves have not been terribly intentional. *Zippy* comes out of my subconscious, like most strong cartoon characters. I did not create him (or any of my early stuff) out of commercial consideration. Underground comics were an avenue of self-expression, like any other art form. Gearing the work to an audience was not something I was interested in or capable of. I'm just glad enough people want to read what I do to make me a living in comics."

While Griffith's creation is clearly unusual, his working methods are quite like the methods of most other cartoonists. "I keep a notebook and jot down ideas as they come to me. If I've used up all the ideas in my notebook, I stare straight ahead at my drawing table until I either start working or fall asleep. Though cartooning is clearly a marriage of writing and drawing, I think writing (real believable characters with something to say beyond a simple gag) has a slight edge and should be the foundation of a strip or story. I try not to repeat myself and I read and reread the masters (McCay, Herriman, Segar, Bushmiller, Crumb) to inspire me. I also travel a lot and keep sketchbooks to recharge the batteries."

Bill Griffith's advice to the aspiring cartoonist is, "Read a lot, watch a lot of TV, see a lot of movies, travel, suffer, take life-drawing classes, go into psychotherapy, visit museums, get work on a weekly newspaper and then break into the big time. I could say keep your day job—which isn't a bad idea—but I think the best way to learn the ropes is to get published as soon and as often as possible. There's no better teacher than seeing your scribbles in print. Alternative small magazines and weekly newspapers are good places to start."

on every card. Neuters are human characters of no particular gender used on greeting cards to appeal to both men and women buyers alike. Animal characters are often used on cards instead of humans, to sidestep the task of trying to address the specific age, gender or race of each individual card buyer. Visit a greeting card shop and study the way each character is used as a spokesperson and surrogate friend.

Comic strip characters are more complex than magazine characters and greeting card characters. A successful comic strip will run for decades, and readers will become very familiar with these characters. Often great comic strip characters will come to seem very much like real, live friends and neighbors. As readers we see our favorite comic strip characters laugh, cry, lose their temper, eat, sleep, go to work, get fired, fall in love, experience pregnancy, raise families, and sometimes (as in *Gasoline Alley*, *For Better or For Worse* and *Baby Blues*) we even watch characters grow older.

We develop fairly intimate relationships with comic strip characters over the years. Developing and nurturing this sort of personal relationship requires characters of depth, with many layers of emotion. Hagar the Horrible, for example, is a loudmouth barbarian, big and bold and larger than life, but he is also a gentle little pussycat at times. Likewise, Harriet and Stanley from *The Better Half* experience and express the full range of emotions and challenges that affect real-life marriages; their moods and relationship change from day to day, just like the real marriages of their millions of readers. Great comic strip

characters must not be two-dimensional—they must have full, rich, exciting and amusing personalities that are always interesting and always surprising.

ow did the great cartoonists create their famous characters?

Many famous cartoon characters were never *created*, they were *discovered*.

- Woody Woodpecker, for example, was discovered when a pesky woodpecker was intruding upon the honeymoon bliss of animator Walter Lantz and his new bride.
- Johnny Hart originally created a cast of cavemen for *B.C.* in a somewhat contrived manner, but soon discovered fascinating character traits among the personalities of his friends, coworkers and relatives, and these traits were applied to his cavemen with great success.
- The character of *Dennis the Menace* was discovered when Hank Ketcham's real-life son Dennis was proclaimed to be a "menace" by Ketcham's first wife.
- *Hagar the Horrible* was an affectionate nickname given to creator Dik Browne by his sons. In fact, Browne and Hagar could have been mistaken for identical twins.
- In *The Family Circus*, Billy, Jeffy, Dolly, P.J., Mommy and Daddy were all based on the real-life family of creator Bil Keane as they were in the late 1950s and early 1960s.
- Even the bizarre *Zippy the Pinhead* was inspired by real life after creator Bill Griffith discovered the ob-

Cartoonist Profile:
RICK STROMOSKI

R ick Stromoski began his career as a magazine cartoonist, but has become better known as a successful greeting card creator. His greeting card creations have even been nominated for the prestigious Reuben Award, professional cartooning's equivalent to the Oscar and Emmy.

Like many great cartoonists, Rick Stromoski recommends art school for the young, aspiring cartoonist. "Attend an established art school that has working artists on its faculty . . . take every class available. Expand your mind . . . it is your most valuable tool.

"I entered the greeting card field as a way of supplementing my income and diversifying my cartoon endeavors. I have always drawn and sent handmade cards to friends and family since I was eight years old. It dawned on me sometime in the 1980s that this could be a way of making some money.

"I have sold many single-panel (magazine-style) cartoons in greeting card form. Some cartoons have a natural tie-in to a greeting card sentiment. For instance, I sold a particular cartoon about the Pillsbury Doughboy in a doctor's office to several different magazines. I also sold it as a get well card to a greeting card company. There really is no set format for a greeting card—if there was, I think the greeting card business would be pretty boring.

"My advice to any aspiring cartoonist is never give up. Be prepared for an incredible amount of rejection and small paychecks and a lot of hard work. But if you do not give up, you will succeed. You must also diversify in order to do this. Try your hand at everything. Gag cartoon-

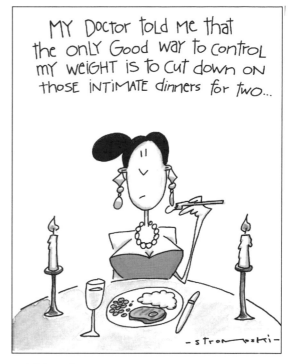

© Rick Stromoski

ing, illustration, greeting cards, newspaper syndication, paper products, animation, anything that entails humor. It is foolish to put all of your eggs into one basket, because all of these industries have downtimes during the course of the year."

"My only other advice is to explore all of the drawing media that are available. And learn to work with color. It will open up so many more opportunities than black-and-white . . . and just do what you really want to do with your life, it's the only one you will ever get. Don't waste it in a job you hate."

ject of his inspiration in the cult film *Freaks*.

- Television's *The Simpsons* was created after Matt Groening discovered the comic possibilities of his own family. Like Bart Simpson, Groening has admitted to having been a troublesome and challenging child. Coincidentally, Groening's parents and siblings in real life are named Maggie, Lisa, Homer and Margaret.
- Originally, Brian Crane created the senior citizens Opal and Earl for his strip *Pickles* simply because he thought nobody was doing a strip about old people. Soon Opal and Earl were discovered to possess many personality traits of Crane and his own wife, and art began to imitate life.
- Tom Batiuk was a high school teacher in Ohio when he discovered the inspiration for his *Funky Winkerbean* characters among his coworkers and students. The star of his *Crankshaft* strip is modeled after school bus drivers Batiuk encountered as a teacher.

Many of the greatest newspaper comics have some degree of autobiographical genesis, which may be the source of the sincerity and honesty that make them so special and so real to their readers.

Take a fresh, new look at the people who are part of your life. Do you know anyone whose personality might

Harriet and Stanley Parker, from *The Better Half,* have fully developed personalities and unpredictable moods just like real people. They have good days and bad days, happy times, sad times, high energy, exhaustion, sometimes they splurge, sometimes they're broke, they love, they dream, they disagree, just like real people . . . this makes it easy for readers to relate to them. On the other hand, they also have unique personalities and quirks, just like real people. No matter what else happens, readers know that Harriet will always be the more mature and stable half of the pair and that Stanley will always be somewhat childlike and a bit peculiar in anything he does. Like most married couples, Harriet and Stanley must work hard to keep the flames of love flickering after many years of marriage. When readers can relate to comic strip characters, they almost feel like they're reading about themselves. And who wouldn't like to read something fun about themselves in the newspaper every day?

Another reason readers come back to their favorite comic strips day after day is the same reason they come back to their favorite old movies and TV shows again and again . . . they want to spend some time with an old friend.

inspire an interesting new cartoon character? Just for practice, turn your friends, neighbors, coworkers and family into cartoon characters. If you have an elderly aunt who's a meddling busybody, could you overstate or embellish her personality to create an interesting cartoon character? How about that obnoxious little kid down the street whose every word and action reminds you of fingernails dragged across a chalkboard? Maybe your boss has some traits you could exaggerate for comic effect? Look into the mirror . . . anybody in there who'd make a good cartoon character?

THE BETTER HALF® By Glasbergen

GLASBERGEN
11-23

"Any fool can buy flowers from a store . . . but did anybody ever plant daisies in his belly button for you?"

THE BETTER HALF® By Glasbergen

GLASBERGEN
11-21

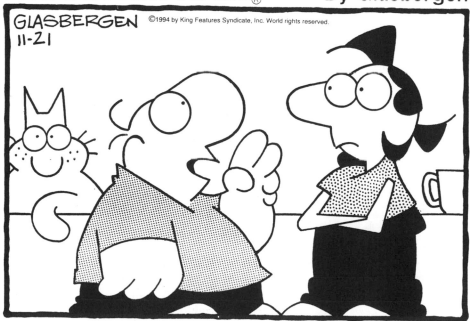

"We have two nostrils, but only one mouth . . . so wouldn't it be twice as nice if we kissed with our noses?"

Cartoonist Profile:
CHRIS BROWNE

Hagar the Horrible has the ingredients of a memorable cartoon character. His horned helmet, expressive eyes and mouth, untamed beard and hairy tunic give him the appearance of a big bear of a man. Yet readers of this enormously successful strip know that Hagar is as soft inside as he is crusty outside. Hagar has both a memorable appearance and a memorable personality that have assured his popularity for more than twenty years.

Hagar was created by the late Dik Browne. Before creating Hagar, Dik collaborated with Mort Walker on the popular *Hi & Lois* strip. Prior to syndication, Dik drew *The Tracy Twins* for *Boy's Life* magazine and worked for an advertising agency where he created original designs for the Chiquita Banana character, the Bird's Eye bird logo, and a modernized version of the Campbell's Soup kids. Dik's background in art and cartooning established a strong foundation upon which he built his syndication career and contributed greatly to his success with Hagar. Dik is considered by many to be one of the most talented artists ever to create a successful comic strip.

"I learned cartooning from my father," says Chris Browne, who assumed production of Hagar after his father's passing. "In a sense I was an apprentice, learning a craft from an old master, just as artists have learned from master sculptors and painters for centuries. When I was a child, my toys were art supplies. While other kids were tossing a football around with their dads, mine was teaching me how to sculpt in clay, mix papier-mâché, cross-hatch with a pen, use watercolors, and draw."

To enhance creativity, Browne recommends the book *Drawing on the Right Side of the Brain* by Betty Edward. He also offers this advice: "If you're thinking of a career in comic strips, try your hand at magazine gags first. See if you can work up to the point where you're sending a dozen finished high-quality cartoons a month to magazines. If that sounds like a lot, it is, but if you were doing a comic strip, you'd be doing thirty gags a month, and because there are multiple panels to a daily strip and even more on Sunday, a syndicated comic strip can mean you'll be drawing between 80 and 128 individual panels every month of your life for the run of the strip. So try magazine gag cartooning first—see if you enjoy it before trying to go off the high board. Magazines are also good, because if they don't like what you sent this month, next month you get another shot. You can do a lot of growing at a magazine. I'm embarrassed to look at my early magazine work now—but the fact is, it was great on-the-job training."

Like virtually every cartoonist in the business, Chris Browne admits that "The hardest part of comic strip cartooning will always be the writing. The drawing you learn and just do it, like riding a bike. For writing you have to think of something that's funny and that people can relate to, but it can't be too risqué, too out of date, too in, too personal, too political, too naive. It can't be similar to, or the same as, any other gag you've ever seen; it must be character-driven, must avoid puns, and can't offend anyone on the planet. And it has to work in the time period and style and setting of your strip, and of course it has to work with the characters. Then all you have to do is do it again and again and again and end up with 365 good cartoons a year—but of course, to get to those, you'll have to write several times that number. See what I mean? Drawing is easier. Much easier."

To meet the unrelenting challenge of idea-

Reprinted with special permission of King Features Syndicate.

writing for *Hagar the Horrible* and other projects, Chris has discovered a variety of ways to stimulate creativity. Sketching is one trick he uses to stimulate creative thinking. "I bring my sketchbook into the bathroom in the morning and to my bedside at night. A lot of cartoonists do this. Also, I read a lot. I read a lot of little chunks of the paper, magazines and paperbacks. I love bookstores. I turn on *Headline News* and get a quick glimpse of what's going on. I go for walks. I lug my sketchbook to restaurants for brunch and listen to people. I eavesdrop mercilessly. I write down the funny or ironic things people say. Sometimes a word or phrase will set me thinking. When all else fails, I call friends and shoot the breeze. I doodle as we talk. Into every phone call, a few funny things fall. Write them down! Later you can sculpt them into usable gags.

"Sometimes I do get stale. I have good and bad days. You have to focus on today. I believe it helps if you feel a real connection to your work. Don't waste your time doing cartoons you don't feel good about. Put your heart into what you're doing. My father based his strip *Hagar* on his family—did it help? Well, he never ran out of material! Now I do the same, turning my wife's and stepdaughter's quips into the life's breath of the Hagar family. This is fun. Yes, I'd say keeping it fun helps you keep an edge, too."

Despite being syndicated in nearly 2,000 newspapers, Chris Browne does not feel that his career is resting on a comfortable plateau. "Actually, I am still an aspiring cartoonist. I still try to sell new comic strip ideas, get them turned down, try to sell to major magazine markets. Success has a mercurial quality; it's difficult to achieve for anyone. Success is almost too Western a concept when you're talking about artistic fulfillment. If you can make enough money to live on while expressing yourself, obviously you have some success."

Creating Funny Cartoon Ideas

When I'm starting a new cartoon, which should come first, the drawing or the joke❓

Always start with a funny idea. In cartooning, funny ideas are called *gags*. Unless you're just sketching or doodling for fun, you need to come up with a funny gag before you begin to draw a funny, professional-style cartoon. The gag is the foundation upon which a great cartoon is built.

Some cartoonists create gags by sketching little drawings on a note pad, but these are only doodles meant to get some creative juices flowing. Actual finished art is never begun until *after* the necessary gags are written.

If you did your drawing first, what would happen if you couldn't think up a gag to go with it? All the time you spent on that drawing would be wasted! Drawing before you have an idea is like driving your car for two hours before deciding where it is you wanted to go in the first place.

I've been trying to sell cartoons to magazines, but I'm not having any success. One editor sent me a note saying I need to work on my ideas. How can I get better❓

You'll improve your gag writing the same way you improve your drawing: with many hours of study and practice! Study cartoonists you enjoy and write as much funny material as possible as often as possible.

Study all forms of humor and absorb their influence. Subscribe to one or more daily and Sunday newspapers and get into the habit of reading the comics every day. (Better still, read the entire paper! Everything you read is "brain food" that may lead to your next great idea!) The next time you're in the mall to buy a CD, buy a couple of comedy cassettes instead and listen to them while you're drawing. Spend more time in greeting card shops and read as many funny cards as you can. Buy a few if you can afford to and start a card collection read through for inspiration.

Buy or borrow cartoon books and read them to become more familiar with successful humor methods. Read different collections, not just the popular collections. Challenge yourself to grow by reading books that might not be your first choice. For example, if your sense of humor tends to be dark or sarcastic, buy a few *Family Circus* or *Cathy* books and expose your brain to a new source of creative fuel. On the other hand, if your work tends to be too cute, spend a weekend reading cartoon books by Sam Gross or John Callahan, two masters of weird and sick humor. No matter what sense of humor you have, try not to get stuck in a rut!

One of the best and least expensive ways to study hundreds of successful magazine cartoons is to subscribe to *Gag Re-Cap*. Each monthly issue gives a detailed listing of every recent cartoon published in dozens of American magazines (including trade publi-

"This CD-ROM has the Bible in several different languages, including English, Spanish, French, Greek, Hebrew, Conservative and Liberal."

cations, medical journals, adult magazines, women's magazines, children's magazines and general interest publications). By studying *Gag Re-Cap*, you'll learn what kind of cartoons are finding success with each specific magazine listed. Most issues also contain a few pages of marketing news as well, to help keep cartoonists informed on a variety of freelance issues. For subscription information, contact Al Gottlieb, Gag Re-Cap Publications, 12 Hedden Place, New Providence, NJ 07974. For anyone who is serious about becoming a great cartoonist, *Gag Re-Cap* is mandatory reading!

Some cartoonists claim that watching television is a good way to study humor, but this habit may or may not be helpful to you. If you're like most people, staring at the television is a passive activity done with your brain in low gear. Unless you're taking a lot

of notes while you watch, chances are you're not thinking or learning much. On the other hand, if you watch comedy programs with a notebook and pencil in hand, perhaps you can learn to dissect material and discover how humor is constructed. Taking notes while you watch television may also be a good way to study character development and interaction, which may help if you're trying to create original characters for a comic strip or other creative project.

While studying humor is important to your development as a cartoonist, it is more important to practice your gag writing as often as possible. If free time is limited, practice writing one day and drawing the next day. Learning to write humor is not much different from learning to play the piano or mastering a sport—the more you practice, the better you get!

This cartoon, like many others I've done, began as a sketch in a notepad. Starting with a sketch often results in a better, funnier cartoon because you can work and rework a drawing until all of the elements are strong and visually interesting.

Cartoonist Profile:
TOM CHENEY

Tom Cheney is one of the most prolific magazine cartoonists in the business. Thousands of his cartoons have been published in *Punch, National Lampoon, The Wall Street Journal, Good Housekeeping, New Woman, Omni,* and dozens of other publications. He is also a regular contributor to both *The New Yorker* and *Mad* magazine, two of the most desirable markets for any cartoonist. Cheney's hilarious cartoons have won him a tremendous following, many of whom are also his peers and competitors.

As with many great cartoonists, success did not come easily or quickly for Cheney. "My biggest break came when my first cartoon appeared in *The Saturday Evening Post.* Up until then I'd spent two years agonizing over constant rejections. Just before I sold the cartoon to the *Post,* I'd switched to a different pen, changed my drawing style and decided to go completely off the wall with the humor. Fortunately, it was the right move and it seemed that my work began to catch on from there. Within a year I sold my first cartoon to *The New Yorker.* I gradually got my foot in the door at other magazines and was able to go full time into cartooning . . . one of the scariest things I've ever done.

"Rejection slips are like rain, and even the pros get drenched. I don't think that rejections are a valid judge of a cartoonist's work. Cartoons get rejected for thousands of trivial reasons in a marketplace that changes like the weather. To ease the disappointment of rejection, I simply ask myself why I got into this business and why I'm continuing: I love to draw, I love writing humor, and I can't think of anything else I'd rather be doing. I was drawing cartoons long before I ever got paid to do it, and it will take much more than a barrage of rejections to make me stop.

"I try to maintain a routine time slot each day for writing and drawing, keeping the sessions separate so I can give 100 percent to each. I reserve the evening for writing. At night there are fewer interruptions and I can maintain a longer train of thought on a particular concept until it becomes a plausible gag. Setting aside a specific time each day for gag writing has helped me keep a steady creative pace without burning out. The routine itself seems to stimulate creativity."

Recently Tom Cheney has begun to explore the role a computer could play in the future. "I don't think the computer will ever endanger or replace the printed cartoon, but I do believe it's established a growing audience of its own. The digital medium is still overrun with empty high-tech graphics and is crying out for the talents and skills of artists who, up to now, have only been comfortable at their drawing tables. Cartoonists are destined to make a very big splash with computers and I'm keeping myself updated on all of the latest software and tools so I'll be ready to join in the fun. After having seen my

own work animated by my wife on her computer, I'm convinced that the possibilities are endless.

"For anyone interested in cartooning as a career, I highly recommend a liberal arts education with an emphasis on art. On the surface, cartooning might look easy, but beneath it all cartoonists possess a working knowledge of anatomy, perspective and composition. Those are the building blocks of great cartoons. Learn how to write well and familiarize yourself with the fundamentals of humor. My hat goes off to any aspiring cartoonist out there who's making sacrifices in his or her personal life to give more time to the drawing table. These are the cartoonists who are destined for greatness."

"Does it have a radio?"

© 1994 by Tom Cheney.

Are there any good books that teach cartoon gag writing**?**

There are a few books that teach gag writing for cartoonists, but you may not find them helpful. In many cases, these books will show you a published cartoon (or simply describe it) and then explain to you why it is funny and what humor devices were employed in the gag. This teaches gag writing backwards, beginning with the finished product and explaining why it works. Unfortunately, you do not begin with a finished cartoon, you begin with a blank sheet of paper. You need to learn how to travel from the blank page to the finished product. Being able to identify a hidden element or cliché is not the same as being able to create one. Some cartoonists endorse this style of teaching and others do not. Browse the bookshelves for this type of material and decide for yourself.

On the other hand, there are some other books which you may find more helpful. Each of these books is full of tips on how to develop your comic mind and create successful humor from start to finish. Here are a few suggestions:

- *Comedy Writing Secrets* by Melvin Helitzer (Writer's Digest Books, F&W Publications, 1507 Dana Avenue, Cincinnati, OH 45207)
- *Stand-Up Comedy, The Book* by Judy Carter (Dell Publishing, 666 Fifth Avenue, New York, NY 10103)
- *How the Great Comedy Writers Create Laughter* by Larry Wilde (Nelson Hall Publishers, 325 West Jackson Boulevard, Chicago, IL 60606)
- *How To Be Funny, Discovering the Comic You* by Steve Allen (McGraw-Hill Book Co., 1221 Avenue of the Americas, New York, NY 10020)

One more book you should look for is *A Whack on the Side of the Head, How You Can Be More Creative* by Roger von Oech. (Published by Creative Think, Box 7354, Menlo Park, CA 94026.) This is not a book about cartooning, but it can help you become more creative. Roger von Oech is the president of Creative Think, a company that conducts creativity seminars for many of the world's leading corporations where creativity and innovation are the lifeblood of success. His book will teach you how to unlock your mind, see things differently, challenge your old ways of thinking, and increase your creative output. If you're not feeling as creative as you'd like, *A Whack on the Side of the Head* may be what you need. (If you own a computer, you should also explore the interactive software program, Creative Whack Pack.)

I'm not interested in doing magazine cartoons or comic strips. I'm interested in humorous illustration for books, greeting cards, advertising and such. Do I need to be funny for this kind of cartooning**?**

If you want to be a humorous illustrator, you must learn how to be humorous. Humorous illustrations are not just funny pictures, they are funny ideas communicated by funny pictures. Without a solid understanding and mastery of humor, you may not

Cartoonist Profile:
JERRY DUMAS

For more than thirty years, Jerry Dumas has been earning a reputation for being one of the finest idea men in the cartoon business. He may be best known for his long association with Mort Walker's *Beetle Bailey*, but has also been writing and drawing *Sam and Silo* for King Features Syndicate since the late 1970s. Dumas has also worked on *Hi & Lois*, was the author of the *Benchly* comic strip which was illustrated by Mort Drucker, and *Rabbits Rafferty* which was drawn by Mel Crawford and featured as a children's book and a syndicated panel. His cartoons have appeared in *The New Yorker* and he has written articles and poetry for such lofty publications as *Connoisseur* and *The Altantic Monthly*.

"I am still writing one-third to one-half of all the gags for *Beetle Bailey*, Dumas explains. "Coffee and a good night's sleep really help. I usually start by staring at a blank sheet of paper and visualizing two characters together, talking. Or I think of a funny picture we haven't already done—this is difficult—and work backward from the last panel to first. Sometimes I read dumb articles or advertisements I'm not at all interested in, knowing that gags can come from any strange combination of words and phrases.

"In my opinion, the best gags come out of character. I know who Beetle is, and so do you, and we both know how he is likely to react in a given situation. Same for Sarge, Zero, and General Halftrack. I like to get a combination of funny words and pictures. I usually dislike strips that have too many words. It's great to have a funny picture. Of course, it's also great to have funny lines you can tell the next night at a dinner party. You can't tell a funny picture."

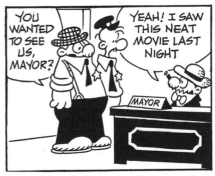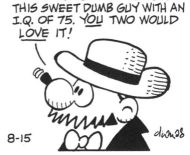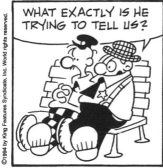

Reprinted with special permission of King Features Syndicate.

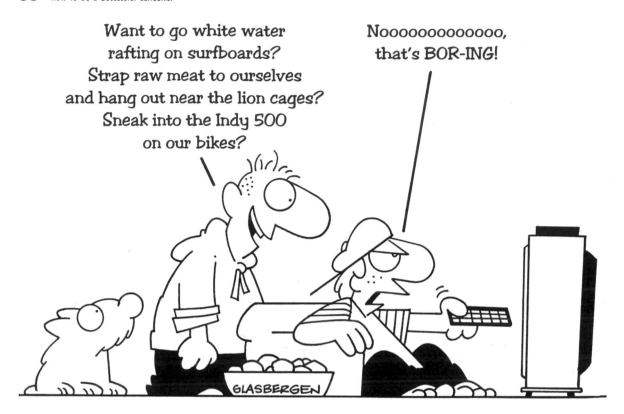

Want to go white water rafting on surfboards? Strap raw meat to ourselves and hang out near the lion cages? Sneak into the Indy 500 on our bikes?

Noooooooooooooo, that's BOR-ING!

GLASBERGEN

This particular cartoon has been published several times by different magazines, mostly ones slanted for a teenage readership. Despite the success of this cartoon, I had my doubts when I drew it. Was it a funny cartoon, or just a little unusual? It's not your typical magazine cartoon with a caption typed underneath, so I wasn't sure if editors would respond favorably to this format. Plus, at the time I was worried that the idea might be too subtle because it's not a visual gag and it's not real jokey, either. Just the same, my instincts told me this was a good cartoon idea, so I took the time to draw it, and I guess my instincts were right after all. But you never know for sure. Sometimes you just have to trust your feelings.

be able to put the essential humor into your *humor*ous illustrations.

If you are a humorous illustrator and you receive an assignment from a magazine editor or art director, you must find a funny way to illustrate the contents of the article—even if there is nothing inherently funny about the article at all. Your understanding of humor must be sharp enough that you can read the story and then make a humorous commentary with your artwork. Even though you are not writing a cartoon gag, you are making a

humorous statement just the same. Sometimes an editor or art director will tell you exactly what to draw, but often you will be left on your own to interpret the text in a humorous way.

For practice, pick out an article that is illustrated by a photograph. Read through the article and replace its photograph with one of your humorous sketches. Make sure your illustration makes some sort of statement about the text or gives the reader a clue to the contents of the article. For example, if a newspaper article talks about how exhausted some famous pop star is from touring, replace their stock photo of the star with your own illustration of the singer napping under the lid of his grand piano, being carried onto the stage in a stretcher, singing surrounded by thousands of cups of coffee, or whatever you can imagine to communicate the infor-

mation in the article. Some illustrators use this method to audition for new clients, substituting their illustration for the client's art or photography.

You don't need to master the verbal gag to succeed at humorous illustration. However, you must train yourself to become a creative thinker with a great sense of humor. This requires as much practice as your art, so study humor and learn to be a funny thinker. Remember: Before your hand can draw something funny your brain has to send it a funny thought.

■ have a good sense of humor, and I write some pretty funny cartoon ideas. How can I know if readers or editors will like my ideas?

If I were a stand-up comedian, I could tell if an idea is funny because I could hear people laughing. What's the best way for me to judge my humor**?**

Unfortunately, most cartoonists have little or no direct interaction with their audience. If editors are reading your comic strips or magazine cartoons in their offices, you're not there to hear whether or not anyone laughs. So it's up to you to develop a *gag sense*, an intuitive feeling for whether or not an idea is funny.

The best way to develop a gag sense is to read other cartoons. These are the yardsticks by which you'll measure your own work. After reading thousands of cartoons, you'll become attuned to the attributes of a

"Fresh-ground Cheez-its on those marshmallows, sir?"

© 1994 Jack Ziegler.

Jack Ziegler has been a regular at *The New Yorker* since the mid 1970s. His cartoons have influenced many other magazine cartoonists and have a reputation for being highly creative, but never complicated or difficult to understand. His own influences include Harvey Kurtzman, George Booth and the legendary B. Kliban. "I do my ideas in the morning," Ziegler explains, "after reading some book for thirty or forty minutes, then scanning the *New York Times* for about thirty minutes. I try to avoid breakfast until after I do my ideas."

Cartoonist Profile:
LYNN JOHNSTON

Lynn Johnston's *For Better or For Worse* looks like no other comic strip in syndication, and her gags have a unique style all their own. Her first cartooning job was in a Vancouver animation studio, where she worked in the ink and paint department. Later, during her "hard times," she freelanced and "did everything from setting type to designing cereal boxes, billboards, leaflets, posters, flyers and book illustrations. I learned a great deal more about commercial art than I ever learned in school," she recalls. In 1972, while expecting her first child, she created more than eighty cartoons about pregnancy which were published in a book called *David, We're Pregnant*. That book eventually sold more than 300,000 copies and inspired Universal Press Syndicate to offer her a contract for *For Better or For Worse*, a comic strip with characters based on herself and her own immediate family. "We were the only people who I knew I could draw over and over again with some consistency," she confesses.

Although Lynn's strips are loosely based on her own family life, she must still sit down with a pad and pencil and write ideas for each daily and Sunday cartoon. "Writing is always the toughest part. Actually, I write stories, not gags. I try to have an intimate relationship with the reader so people will feel close to my characters. To get ideas, I sit in my favorite chair and daydream. If I come up empty—usually three hours is my waiting period before I declare it a loss—I get out of my house and walk, shop, visit a friend." To avoid disaster and panic, Lynn tries to allow some room for dry spells now and again. "Sometimes *For Better or For Worse* is a job is a job is a job, and I hate it when that happens. It's like writing a thesis or a novel that never ends—it never goes away, you never get the sense of having *finished*." Traveling and getting out of the studio frequently helps keep Lynn's mind and material fresh. "I also listen to CBC network here in Canada. That helps pass the time and gives me something interesting to listen to while I draw."

Lynn often receives mail from fledgling cartoonists and has plenty of strong advice for beginners. "Know how to entertain an audience, how to perform. Take drama classes, learn how to act, *feel* the expression you have to draw. Don't take the kind of attitude that says 'If my readers don't get my humor, too bad!' If your work isn't selling or being looked at favorably by an editor, *change what you're doing*! I get stuff from artists who say 'What am I doing wrong?' If you tell them, they're insulted because they love what they're doing! You have to have a love affair with your characters—they are extensions of you. So putting these 'people' aside is like going through the agony of divorce and the frustration of finding a new love—do it! You are doing a performance for an audience! If your play is closing, people, take some direction, fire some actors and rewrite your play! It's hard, but that's what it takes for a successful entertainment medium—the willingness to see the flaws in your performance! Don't be too arrogant to change."

For Better or For Worse® **by Lynn Johnston**

Frank and Ernest, by Bob Thaves, is a magic combination of modern social/political humor and old-fashioned, Laurel-and-Hardy-style comedy. Frank and Ernest are nomads of the comics page, with no set jobs, location, setting or theme. One day they might be herding sheep, the next day they may be working for the postal service or looking down at Planet Earth from a cloud in Heaven. Some days Frank and Ernest may even show up in the form of bugs, dogs or space aliens! This sense of freedom and anarchy gives *Frank and Ernest* a freshness unlike anything else in the funnies.

Bob Thaves, an industrial psychologist by trade, began his cartooning career as a successful magazine freelancer. In the mid 1970s Bob transferred his talents from magazines to comic strips and landed a contract with the NEA syndicate. "Since the time I could first hold a pencil, I've simply progressed from one level to another," explains Thaves. "High school publications, college publications, then small magazines, large markets—and then I was able to get a syndication contract on my first try. It all seemed to be just a single, continuous, progressive flow. I *tried*. That alone makes a big difference. Those who don't succeed often don't because they didn't try!

"I believe that cartoonists should educate themselves *broadly*. Formal education is great, but should be vastly amplified by reading, travel, and other forms of learning. The cartoonist should prepare himself for the work by acquiring as broad and deep a fund of knowledge as he can.

"Become computer-literate. The relevant technology is mushrooming and is beginning to offer rich alternatives for creation, archiving and transmission of comic art. It is imperative to accept, learn and use the technology. Print media are no longer the main or only venue. Do not think of yourself as a magazine cartoonist or a syndicated cartoonist. Think of yourself as a creator who has a copyrighted database (your cartoons) that you can package in a variety of markets. For that reason, it is absolutely essential that you keep ownership of your own creation—keep your copyright. You can license it or contract it to syndicates, but don't just hand it over to them. Get a lawyer and retain control of your product. If you don't, you'll regret it. Trust me."

Despite his years of success, Thaves has no magic formula for creating great cartoon ideas. "There is no one thing I do. Usually, I just sit down at my desk or drawing board and, driven by deadline pressure, I tough it out. I just start

playing around with half-formed ideas and work at getting them into usable form. It doesn't always work out, but in syndication it has to go in the mail anyway. The deadlines are completely unforgiving and the rule is: 'We don't want it good, we want it now!'

"I figure I'm doing a good job if I have about the same ratio of hits to misses as a really good baseball hitter: A .350 to .400 batting average is very good, I think, in syndication.

"I think individuality is very important. The really great cartoonists do something different that nobody else does. They have an individual personality and they're totally unique. Great cartoons also seem to have an energy to them and a sense of passion. A great cartoon also has an emotional impact on the reader.

"I guess I just like cartooning and even after all these years I can still get terribly excited about a really good gag or a new theme for my comic strip. I read various artist magazines, watch animation, and am always on the alert for new and different ways to do things. I can still get a thrill out of seeing something by somebody else that is totally new and boldly innovative."

Frank and Ernest

good cartoon. Soon you'll recognize those same characteristics in your own ideas. Reading thousands of cartoons will help make you an expert on cartoon gags—then you can apply that expertise to your own work!

As editors begin to accept your work, you'll get a feel for which ideas are successful and which are not. This feedback will help you judge your new material. Having an editor accept one of your cartoons is comparable to having an audience laugh at a joke told by a comedian. Getting that cartoon reprinted in another publication is like a standing ovation.

Another way to measure the quality of your humor is to show it to someone else in person—if you're brave enough! After you finish a few magazine cartoons, comic strips or greeting cards, ask people to give you their opinion. Solicit feedback from your spouse, kids, coworkers, friends and relatives. Accept their opinions gratefully and don't argue with them or accuse them of being stupid if they don't appreciate your humor! If people are confused by your cartoons, look for a way to communicate your ideas more effectively. Pay attention to what gets a good response and what doesn't and try to learn from it.

Unfortunately, there is no guaranteed way to judge the quality of your work. Even experienced professionals are never 100 percent sure a particular gag will hit with a big bang or just a dull thud. Humor is subjective, and not everyone will agree on what is funny. The cartoon one editor rejects may seem absolutely riotous to another. With practice, you may broaden your appeal so more people will agree on the quality of your work.

Are there any solid rules for humor? Do professional cartoonists or comedians follow any certain formulas that guarantee a laugh?

There are no rules for humor or comedy, but there are some elements most professionals might agree on.

The element of surprise. In a joke or cartoon, the element of surprise is something unexpected that makes you laugh. For example, you expect a typical middle-aged businessman to behave in a mature and perhaps stuffy manner; so if he's in a cartoon, dressed in a diaper and babbling like a one-year-old, that would be a surprise, and you would probably laugh. Likewise, if you grew up believing that two plus two equals four, you would probably laugh if someone showed you an outrageous reason why two plus two can also equal eighty-seven.

Similarly, many gags are built from a surprise formula consisting of (a) the setup and (b) the punch line. The setup prepares you to expect a particular outcome, then the punch line takes a turn and hits you with something totally unexpected. Many standup comics use this formula to great effect, and comic strips are a particularly good way to use this form of surprise. Many cartoons and strips in this book utilize this formula effectively.

The element of exaggeration. This is just another form of surprise, only bigger, bolder and more outrageous. Nobody would laugh at an ordinary plate of spaghetti and meatballs, but they might laugh at meatballs that are six feet tall, rolling out the cafe door, bouncing off passing taxis, bowling over little old ladies and their poodles, and leaving a trail of red

sauce several blocks long! Exaggeration is a common element in many cartoons. Exaggeration can be done visually, with wild pictures, or verbally, with wild statements or dialogue.

The element of truth. The best humor nearly always contains some element of truth. Truth is the element most of us can relate to and identify with, the foundation upon which most great humor is built. Great humor is usually created through the distortion or exaggeration of some truth we all recognize or believe in. Without a foundation in reality, humor becomes false, contrived and pointless. For example, a clever gag about a talking toaster probably won't make much of an impression on anyone because toasters don't talk or think, and even if they did, we probably wouldn't care what was on their mind. On the other hand, a talking dog might be funny, because our pets are actually part of the family; we interact with them and probably would be interested in what they have to say! Great cartoonists are observant people who have the ability to see the world differently, to recognize those universal truths we all share. Examine your own gags. Do they contain an element of truth, or are they so far removed from reality that readers can't relate to them?

For more insight on what constitutes successful humor, take the time to read books on comedy writing. Also, examine the cartoons you read, and pay close attention to greeting cards and stand-up comedians. Learn to dissect humor and figure out how surprise, exaggeration, and truth fit into the different styles of humor you encounter every day.

A famous cartoonist once advised me, "Never overestimate the intelligence of the public!" Is this good advice? Are readers really stupid? Should I write simple, brainless cartoons that are easy for people to understand?

To assume that readers are stupid would be a mistake and an act of arrogance. People who take the time to read a newspaper or a magazine are curious people. Curious people want to know more about what's going on in the world around them. They're open to new ideas, insights and information. They are intelligent people who read and are putting forth the time and effort to learn something new. Even people who read celebrity-infested tabloids are to be respected as curious people with an appetite for exciting news and information. As a group, readers are likely to be more intelligent than nonreaders. Don't insult them by writing down to them.

On the other hand, your cartoons should not be difficult to understand. After all, they are cartoons, not puzzles. Your job is to entertain readers, not impress them with complex sentence structure or uncommon words they are not likely to recognize. It is your job to communicate your funny ideas clearly and efficiently. It's not the reader's job to sit and wrestle with your work, trying to figure out what it is you're trying to say.

A great cartoonist is one who has the ability to convey complex and interesting observations in the simplest terms. Charles Schulz's *Peanuts* strip, for example, has never been wordy or complicated, yet there have been entire books written about the deeper meaning of Schulz's gags.

Likewise, a one-panel political cartoon can be as thought-provoking as an editorial of one thousand words. The ideas behind your cartoons may be deep and meaningful, but the cartoon itself should be simple and fun to read. If your cartoons are difficult to understand, readers and editors will be turned off because you have not proven yourself to be an effective or exciting entertainer or communicator. Simplicity is the hallmark of a great cartoon.

How do famous cartoonists create their funny ideas?

Every great cartoonist has his own method for creating funny gag ideas. Their writing methods are as individual as their drawing styles.

- Mort Walker doesn't waste any time staring at a blank notebook—he just starts writing down whatever comes to mind, getting his pencil into motion with the confidence that funny *Beetle Bailey* ideas will eventually begin to flow from his brain to the paper.
- Pat Brady keeps a small tape recorder in a fanny pack he wears all week, collecting thoughts every day that will later be turned into new gags for his strip *Rose Is Rose*.
- Bud Grace enjoys a two hour walk every morning and uses this time to begin formulating new gags that will later be written down for use in his *Ernie* strips.
- Tom Cheney creates his ideas for *The New Yorker* and *Mad* magazine between 8:00 P.M. and 2:00 A.M. when he can be assured that there will be as few interruptions as pos-

sible from the outside world.
- John McPherson finds inspiration for his *Close to Home* cartoons by browsing through *Good Housekeeping* and other family magazines, searching for tidbits that will ignite a spark in his brain.
- Political cartoonist Bill Schorr begins his day by searching the newspaper for an interesting and newsworthy topic to get angry or excited about. This helps him form strong opinions for his syndicated editorial cartoons.
- Lynn Johnston claims to be a habitual procrastinator and doesn't actually begin writing gags for *For Better or For Worse* until deadline pressure prevents her from doing anything else.

Clearly, every cartoonist has his or her own way of doing things. It's up to you to experiment and find the method that works best for you. Read the cartoonist profiles and comments scattered throughout this book, paying attention to each person's creative methods, and then try them to see if they will work for you, too.

While famous cartoonists have different humor-writing habits, their methods for creating new gags seem to be quite similar. The most common method most cartoonists use for getting funny ideas is called *free association*. For cartoonists, free association means to freely link one idea to another and another until a funny thought begins to take shape. For example, you might begin a session of free association by jotting down the word *penguin*. Next, your mind begins to associate the word *penguin* with other penguin-related words, ideas and phrases. For example, the word

WANDA FINALLY FINDS A MOMENT ALONE WITH HER THOUGHTS...

I NEED TO BE MORE ORGANIZED.

AM I A GOOD MOTHER?

AM I GIVING DARRYL ENOUGH ATTENTION?

IS THIS HOW OTHER WOMEN FEEL?

AM I STILL ATTRACTIVE?

AM I HAPPY?

WHAT ABOUT MY CAREER?

WHAT IF I'M NOT DOING THIS RIGHT?

AM I BECOMING JUST LIKE MOM?

WILL I EVER FIT INTO MY OLD CLOTHES AGAIN?

WHO AM I GOING TO GET TO BABYSIT SATURDAY NIGHT?

KIRKMAN & SCOTT

penguin might make you think about things that are black and white; things that are black and white might make you think about racial issues. What sort of racial concerns might a penguin have if it is both black and white? The word *penguin* might take you in a different direction, with associations such as ice, snow, cold, walruses, fish, eating fish for breakfast, fish that go snap-crackle-pop, fish with milk and sugar on them, fish with a toy surprise inside, and so on.

Another way some cartoonists generate new humor is to use funny sketches as a starting point. After you sketch a funny drawing, you can challenge yourself to create a gag to go with it. This is another form of free association with an added visual element. You might begin with a sketch of a worm looking at a plate of spaghetti and meatballs. What funny ideas does this suggest? Would the worm mistake the spaghetti for a family reunion? (In that case, who would the meatballs be—fat relatives?) To create ideas with this method, just sit back, allow your mind to get silly, and start sketching whatever pops into your head. Maybe you'll sketch a woman with eyelashes on her knees, a little boy

being karate-chopped by his teddy bear, or an executive playing a tune on his armpit during an important business meeting. The possibilities for wild ideas are endless.

Another gag-writing method many cartoonists use is called *switching*. Switching is the practice of reading someone else's cartoon and making some sort of change to turn it into a new and original cartoon. For example, you might read through a book of cartoons and find a funny gag about a cat scratching someone's stereo speakers. Now take that same idea and switch an element or two in your mind until you have an entirely new cartoon. Your final cartoon might show a cat at Woodstock scratching speakers that are 50 feet tall or a cat pushing herself to scratch for a long period of time to get an aerobic high. However you change an idea, make sure your switches are substantial enough to create an entirely new cartoon—there is a big difference between switching and stealing.

Regardless of the methods you use, if you are a creative person with a sense of humor, it will be impossible *not* to create funny ideas. With time and practice, you can transform your raw talent into polished, dependable,

professional skills—just like the famous cartoonists.

How do professional cartoonists get into a creative state of mind, especially if they aren't in the mood to be creative or funny? Are there any secrets or tricks of the trade that professional cartoonists use to help them write funny ideas or feel more creative?

While every cartoonist is different, here are a few secrets that many of your favorite cartoonists use to unleash their creative energy.

Coffee. For some reason, coffee and writing seem to go together. According to Universal Press Syndicate, Gary Larson (creator of *The Far Side*) claims: "I don't know where my ideas come from. I will admit, however, that one key ingredient is caffeine. I get a couple cups of coffee into me and weird things just start to happen." Too much caffeine, of course, will make you too jittery to concentrate, but two or three cups of coffee might speed up your thought processes and help you feel more creative. However, funny ideas are not manufactured in a coffee cup, and caffeine by itself will not transform you into a comic genius.

Exercise. Many people claim that creative energy is directly related to physical energy. If the body is energized by exercise, the mind is energized by exercise as well. This does not mean you must run a marathon before each idea session, but you will probably find that a brisk walk can be very helpful when you want to feel energized. You may also find that exercise, rest, and other good habits which promote consistent high energy are some of the best ways to cure or prevent writer's block.

Routine. Most great cartoonists have an established, unchanging routine. Following a routine helps build confidence and productivity by assuring the cartoonist that the same methods that worked yesterday will work again today. Other creative habits might be built around location (writing ideas in the studio, den, outdoors, library), time of day (writing before breakfast, after exercise, late at night), body position (sitting, reclining, lying down), tools (notebook, sketchpad, word processor), and reading (magazines, *Gag ReCap*, cartoon anthologies, the daily newspaper). Some creative habits may depend on mental preparation routines such as meditation, visualization or prayer.

Brain Food. Great cartoonists realize that they must feed their brains with new information every day. Brain food (new ideas, experiences and information) is the raw material that creative ideas are made from. To get several servings of brain food every day, read from as many different sources as possible, learn to be more observant of the world around you, listen carefully when people talk to you, listen carefully to other people's conversations, listen to talk radio or books on tape while you draw, and try new experiences. Train yourself to become extremely curious and to feed your brain as much new material as possible because this is where your ideas will come from. The nature show about seagulls you watch tonight may become the cartoon you write tomorrow or next year. Your friend's conversation about his wife's jealousy may inspire a big cartoon

sale to a major magazine. An article about "How To Solve Your Credit Problems" may pop into your mind three weeks later, resulting in one of your funniest cartoons ever. Remember: The more information you put into your brain, the more ideas you can get out of it!

Creative Surplus. Even the best cartoonists know that every idea they write won't necessarily be a winner, so they write far more ideas than they need and put aside the weaker gags. Typically, the first few ideas written during a gag session are little more than a warmup for better ideas later in the session. If you need six ideas, try to write ten, fifteen or more ideas, because the first six you write may not be the best of the bunch.

Mort Walker is one cartoonist who has used the concept of creative surplus with great success. While *Beetle Bailey* only appears seven days a week, Walker and his staff try to create 50 new and original ideas each week for the strip, thus creating a surplus of more than 150 unused ideas every month. After the best ideas are selected, all of the leftover ideas are put away and given a fresh look six months later. As Roger von Oech points out in his book *A Whack on the Side of the Head*, "The best way to get a good idea is to get a lot of ideas."

Most of the time I can write plenty of great cartoon ideas. Sometimes, though, I can't write a single idea even if my life depended on it. I feel like I have writer's block. The harder I try to work through it, the worse it gets. Is there a dependable cure for writer's block**?**

Writer's block is a problem for all cartoonists at one time or another. For most it's a temporary state, usually caused by fatigue, overwork or another form of stress. If you're normally productive and creative but suddenly find yourself unable to create anything of value, chances are you've got a light case of writer's block.

Try taking some time off from cartooning: Get some extra rest, break your routine, pamper yourself, see a movie or two, read a book, go visit a friend—just do something to get away from the drawing board and freshen up your daily routine. Once you've recharged your batteries, your creative energy should return along with your physical energy. (Creative energy and physical energy often run at the same speed. If your body is tired, your brain will be tired, too.)

Some sources of stress, such as family troubles, divorce, the death of a close friend or relative, financial challenges or health problems, can also cause writer's block. Unfortunately, these kinds of stress won't just go away by pampering yourself or getting some extra rest. The career cartoonist may stockpile extra gags or buy ideas from gag writers during difficult times; the weekend cartoonist may just want to put cartooning aside until life returns to normal. On the other hand, you may find creative work an effective way to manage stress and focus on happier thoughts during difficult times. If you find yourself in a particularly stressful time, talk to your doctor about stress management techniques to help you cope, feel your best, and get your routine back in order.

Turning Your Cartoons Into Cash

What's the quickest and easiest way to become a professional, money-making cartoonist**?**

Unfortunately, there is no quick or easy way to start selling your cartoons. If it were quick and easy, *everyone* would be doing it! But if you've been practicing your cartooning and think you've got something that editors might want to buy, then it's time to explore the options for marketing your work.

The great majority of successful cartoonists have begun their careers as magazine cartoonists. Magazines are a great place to get started because they publish so many cartoons in so many different styles by so many different cartoonists. General interest, trade and specialty magazines publish hundreds of cartoons every month and pay in the range of $5 to $500 for a single cartoon. Some cartoonists have found instant success through magazine cartooning, while others have tried for years before making their first sale and embarking on successful careers. Although established pros dominate the field, most editors seem quite eager to discover funny new talent. Aside from creating cartoons for high school or college publications, magazine cartooning is probably the easiest way for a beginner to get work published.

Magazine cartooning is also a terrific training ground for other forms of cartooning. Many great cartoonists, including Mort Walker, Charles Schulz, Bob Thaves, Chris Browne, John McPherson, Bud Grace, Rick Kirkman, Jared Lee, Rick Stromoski, Joe Kohl and John Caldwell, got their start in magazines before branching out into comic strips, children's books, greeting cards, calendars, advertising and other successful projects.

Magazine cartoons are a fast way to expand and polish your skills because you're not locked into a single cast of characters or a single location. As a magazine cartoonist you're likely to be drawing businesspeople, school teachers, doctors, lawyers, turtles, tigers, time travelers, space creatures, politicians, cute kids, brats, dogs, cats, rats, elephants, unicorns, kings, queens and a zillion other characters. Each batch of cartoons you submit to a magazine may contain ten or twenty cartoons, which means you could be creating as many as a thousand new cartoons in a single year—which is an enormous amount of valuable cartooning experience.

As you gain experience and acceptance in magazine cartooning, you may find your skill level and confidence growing rapidly. At that point you might be ready to branch out into more demanding and specialized forms of cartooning such as comic strips, greeting cards or humor books. On the other hand, if you're successful at selling magazine cartoons, you might be content to stick to that for many years as either a part-time or full-time career. Either way, you will likely find that any time

GLASBERGEN

*"I see we're running a little long this morning. For our final hymn,
let's just sing every other word."*

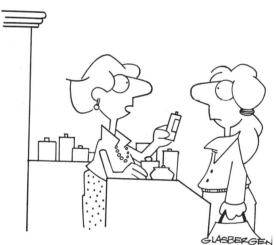

GLASBERGEN

*"This perfume is environmentally safe
and 100% fragrance free."*

Magazine cartoons, such as these, are a great way to break into the ranks of professional cartooning. Magazines will buy hundreds of cartoons this month from scores of different cartoonists, and next month they'll buy hundreds more! Few magazines keep cartoonists under any sort of long-term contract, so the market is wide open to anyone who can create great work.

I exercise
every
morning!
I watch
what I
eat!

Frankly,
my dear,
I don't
give
a damn.

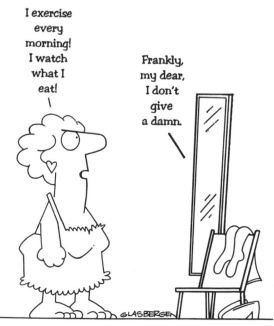

GLASBERGEN

spent on magazine cartooning is time well spent.

When I'm ready to try magazine cartoons, what size should I make them and where should I send them? Do I need an agent or will magazine editors buy cartoons from anyone**?**

First of all, you don't need an agent to sell magazine cartoons. Even the most successful magazine cartoonists rarely, if ever, use agents to sell their cartoons to editors. If your magazine cartoons are good, you don't need a slick, fast-talking agent to open doors for you.

Virtually all magazine cartoonists submit their cartoons through the mail without any fancy presentations or fanfare. Your cartoons can be created right in your own home with simple materials and mailed to editors from your local post office. In many ways, it's a very simple and uncomplicated process. Here's a basic step-by-step method for creating and selling magazine cartoons.

Step 1. Write some funny ideas. Every great cartoon starts with a great idea. If you plan to submit a batch of ten cartoons, then write at least twenty gags and select only the best ones for your cartoons. Make sure your format is similar to the cartoons you see in most magazines—don't write comic strip gags for magazine cartoons.

Step 2. Sketch your drawing in pencil on a sheet of 8½″ × 11″ typing paper. Select a paper that is sturdy, ei-

"I've always had a hard, green shell. For years I thought I was an M&M!"

Magazine cartoons have brought me many new and exciting opportunities. My experience and reputation as a magazine cartoonist landed me a syndication contract for *The Better Half* and opened up other opportunities with greeting card companies, advertising agencies, books, education materials, calendars and much more.

Early in my career, around 1973, I was selling many cartoons to *New Woman* magazine. One day the editor, Wendy Danforth, asked me to do some illustrations to accompany an article for the magazine. Later, she hired me to illustrate a children's book, *Ickle McNoo*, which she had authored. These were my first professional illustration jobs and they came as the direct result of my work as a budding magazine cartoonist. Over the course of the next twentysome years, I've worked hard to build on this foundation, adding to my clientele, little by little, at every possible opportunity. These days I promote my cartooning and humorous illustration services four times a year to a database of more than 1,000 clients and potential new clients.

To create a cartoon for magazines, first write some funny ideas. Write as many as possible and weed out the weak ones.

Next, sketch your cartoon in pencil on heavyweight typing paper. Don't start inking until the sketch is exactly the way you want it. Erase and start over if you need to.

"My dad doesn't express emotions easily, but once he burped 'I Love you' in Morse code."

When your pencil sketch is just right, ink over it with pen, brush or marker. When the ink is completely dry, erase all pencil lines. Neatly print or type your caption beneath the cartoon. If you're using a computer, you can scan your cartoon, add your printed caption in any suitable layout program, then print the finished cartoon on your laser printer. You may also want to archive your cartoon on disk for future use. Be sure to print your name, address and phone number on the back of each cartoon. When you have at least eight finished cartoons, you're ready to make your first submission to an editor.

ther 20- or 24-pound bond works very well, and make sure your typing paper is not the erasable kind or else your pen lines may smudge. Most cartoonists sketch their cartoons with an ordinary no. 2 lead pencil.

Step 3. After your cartoon has been carefully drawn in pencil, trace over your lines with black India ink or felt-tip marker. Make sure your lines are bold enough to reproduce well even if the cartoon is printed very small. You can test how well your cartoons will reproduce by making photocopies at various reduced sizes.

You should also learn to draw reasonably fast. You'll never earn much in sales if it takes you an entire week to create one or two cartoons. Successful magazine cartooning is a high-volume business, so you will need to create as many great cartoons as possible before you can tally up several sales. Because of the high rejection rate for magazine cartoons, top professionals must create as many as fifteen cartoons a day just to sell a few cartoons each week.

Step 4. After your ink is completely dry, erase your pencil lines with a soft art eraser. The Magic Rub eraser by Faber Castell is highly recommended for being non-abrasive, long-lasting and very clean to use.

An alternative method for steps one through three is to pencil your cartoon in nonphoto blue pencil, available in art supply stores. This kind of pencil line will not show up in most types of photographic reproduction, so you don't have to do any erasing after you ink your cartoon. Simply sketch your cartoon in blue pencil, ink over it, then skip right past step four.

Another method is to trace your cartoon in ink after placing a new sheet of paper over your preliminary pencil drawing. Most cartoonists use a light box for this practice. A light box is a shallow wooden or metal box with light bulbs inside, covered with a sheet of frosted glass. The light from the box shines up through your pencil drawing, making it easy to trace onto the second sheet of paper. This method is used by many cartoonists because it eliminates the need for erasing, which can be messy and time-consuming.

Step 5. After your magazine cartoon is penciled, inked and erased, neatly print or type your character's spoken caption underneath the drawing. Be careful to spell all the words correctly and to use accurate punctuation. Most cartoon editors must read thousands of cartoons every month, so don't give them the added burden of having to correct your spelling and grammar. Remember to put your caption underneath the cartoon, not in a word balloon. Word balloons are for comic strips, captions are for magazine cartoons. There are exceptions to every rule, of course, but as a beginner you should learn to obey the rules before you try breaking them.

Step 6. Turn your finished cartoon over and print your name, address and phone number on the back. This is very important. It will identify the cartoon as your property and it will help any lost material find its way back to you. It will also tell the editor where to send your check for any cartoons selected for publication. Print a small code number on the back of your cartoons and record these numbers in a notebook to help you keep track of your submissions.

Step 7. Mail ten to fifteen of your finished cartoons to a magazine that

uses cartoons. Study the magazines sold in newsstands and book stores and select a publication that seems suitable for your work. Don't send sick humor to a family magazine, cute kid cartoons to a men's entertainment magazine, or dog cartoons to a cat magazine. Mail your cartoons flat in a 9″ × 12″ envelope and enclose a same-size, postage-paid envelope for the return of any rejected material. Some cartoonists also enclose an 8″ × 10″ piece of cardboard to help protect their cartoons from being bent or crushed in the mail. Do *not* send the editor a letter about how wonderful everyone says your work is or how badly you need the money for your grandmother's surgery. Just send the cartoons and let the work speak for itself.

If you have easy access to a photocopier, you might prefer to mail clean, high quality copies of your cartoons instead of original art. This has become a common practice among magazine cartoonists, but would not be suitable for any cartoons which feature gray halftone shading. Mailing photocopies instead of original art will protect your art from being lost in the mail or damaged by careless editors. Occasionally an editor may request your original art if a cartoon is being purchased for publication, but usually a clear photocopy will print just fine.

Step 8. Go back to step one and get to work on your next batch of cartoons! Once your first batch is in the mail, forget about it. Don't lie awake all night worrying about whether or not you're going to get rich from your first batch of magazine cartoons (you won't). You might make a sale or two from your very first batch or you may receive several rejections before your first sale. After your first batch of cartoons is mailed back to you, send your rejects off to another suitable magazine. Your cartoons may come back to you in a few weeks or it may take a few months, since every editor responds differently. If an editor has

"I had fun, fun, fun 'til my doctor took the T-bone awaaaaaaaay!"

kept your cartoons for more than three months, a courteous, friendly note may help move things along.

Learn to expect rejection as an inevitable part of cartooning. Even the top professionals often get 70 percent of their magazine cartoons rejected! There simply isn't enough space in magazines to publish all of the thousands of cartoons that are submitted every month by a few hundred magazine cartoonists. Just the same, it only takes one or two good sales each month to substantially increase your personal income. What could you do with an extra $150 or $200 or $300 this month? (Don't forget to put part away for your taxes. Any income you earn from cartooning, even as a hobby, is subject to tax laws, so be sure to put the proper portion away in a special savings account for your extra income taxes.)

When I start submitting cartoons, where do I find the addresses of magazines I want to send them to? Also, how many magazines are buying cartoons? I read someplace that magazine cartoon markets are disappearing and quickly becoming a thing of the past!

While magazine cartoons may not be as mainstream as they were in decades past, there are just as many great cartoon markets now as there have ever been! In addition to highly visible magazines at your supermarket checkout counter, there are dozens and dozens of specialized magazines that buy cartoons every month (many paying rates as good as or better than the big name magazines).

Today's successful magazine cartoonists are making good money selling gag cartoons to medical publications, trade journals, men's magazines, sporting magazines, religious magazines, regional magazines, magazines for cat lovers, magazines for children and teenagers, and many other special interest markets. Almost every special interest group has a few publications that cater to its unique interests. Many of these publications buy and publish cartoons because readers love to laugh at cartoons about their sport, profession, hobby or organization. People love to read about themselves and cartoons are a fun way for editors to make their readers feel special. When you create cartoons for these special interest groups, you'll be cartooning for a very enthusiastic and appreciative audience.

In recent years, the market for magazine cartoons has also extended into electronic publishing on the Internet. As more magazines expand their publishing to include electronic versions accessible by computer modem, this publishing frontier will continue to offer exciting new opportunities for magazine cartoonists.

Here are some ways to find addresses of the publications you want to submit your cartoons to.

1. Browse your local newsstand or magazine shop. Look for magazines that publish cartoons and jot down the addresses in a small notebook. (Better still, buy the magazine and bring it home to study further.)

2. Subscribe to *Gag ReCap* magazine. Each issue lists the names, addresses, editors and payment rates for dozens of cartoon-buying publications. New markets are also reported

in nearly every issue.

3. Buy copies of *Artist's & Graphic Designer's Market* and *Writer's Market* annual directories, published by Writer's Digest Books, 1507 Dana Avenue, Cincinnati, OH 45207. In these books you'll discover more magazine cartoon markets than you could probably submit to in a lifetime!

4. Pioneer new markets. Find a publication that doesn't publish cartoons and see if you can convince the editor to start using your work. If the editor likes your cartoons, then you've developed a brand new market that only you know about (at least in the beginning). If they decide not to buy your creations, just send your work to another publication and try again.

5. If you want to pioneer new markets, take time to consult the reference section of your local library. References, such as *The Standard Periodical Directory* (Oxbridge Communications, 150 Fifth Avenue, New York, NY 10011), include listings for every magazine published in the United States and Canada. Other directories specialize in listings of business newsletters and other special interest publications. There is a wide variety of reference books to explore, so plan to spend a few hours in the library. Select several publications from these listings and mail them photocopied samples of your work. Since these markets are not currently publishing cartoons, a brief cover letter would help explain the purpose of your submission.

Ultimately, if your cartoons are very good, you'll have little trouble finding editors to buy them. It's hard for an editor to say no when she's laughing!

"Someday, son, you'll be old enough to do anything you want . . . but you won't have the time, money or energy!"

Do I need to copyright my cartoons so an editor won't steal them?

Copyrighting your work is not necessary. No copyright notice will stop a dishonest publisher who wants to cheat you, but most cartoon editors are honest people who will not risk their jobs by stealing your work. Although laws vary from country to country, in the United States your cartoons are automatically copyrighted the moment you create them. Essentially, your signature is your common-law copyright. No publisher can obtain your copyright from you without a proper and specific contract. Detailed information on this subject can be obtained from The Graphic Artists Guild, 11 West 20th Street, New York, NY 10011.

Cartoonist Profile:
TED GOFF

Ted Goff's cartoons have appeared in thousands of newsletters, business publications, brochures, books and trade journals. His work has also appeared in *The Wall Street Journal, Air and Space, TV Guide, Funny Times, Good Housekeeping* and *The National Enquirer.* Ted works from his home studio in Kansas City, but freelances for publishers all over the world.

"If you asked me to tell you the secret of drawing and selling cartoons, I'd have to say it's the same secret of running any small business. You have to constantly strive to improve your product and your presentation and to keep finding more customers.

"I have nothing against selling cartoons to the top consumer magazines. I admire the cartoonists who can make their living doing only that. For the rest of us, however, there is no shortage of other potential markets. Besides the well-known consumer magazines, myriads of trade journals, small newspapers, special interest newsletters, association newsletters, in-house publications, textbooks, manuals, and various other publications buy cartoons. Magazine cartoons can also be sold to advertising agencies, public relations firms, design firms, T-shirt companies, seminar speakers, to sales people to use in catalogs and literature, and to small businesses of every sort (to use in flyers, window displays, ads and brochures).

"Your local library will probably have all the resources you'll need to find buying markets." In addition to other market listings mentioned in this book, Ted suggests the following resources: *Encyclopedia of Associations, Gale Directory of Publications, Gale Directories In Print, Gale Newsletters In Print, Oxbridge Directory of Newsletters, Gale Publishers Directory, Standard Directory of Advertisers* and *Literary Market Place.* "This is just the tip of the iceberg. A large city library will have walls of directories covering a multitude of subjects. Dig through them and find new kinds of markets to contact."

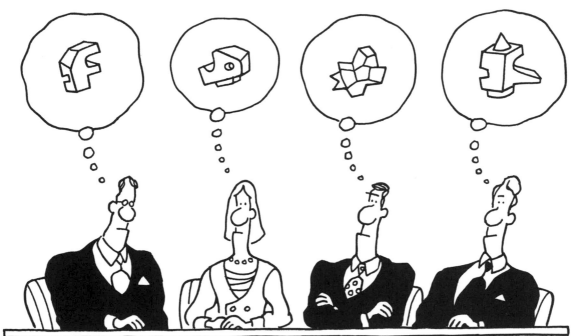

THE CUBE IMPROVEMENT COMMITTEE

What does it mean if a magazine buys *first rights* to a cartoon? What is the difference between *first rights*, *all rights* and *one-time rights*?

When you sell a cartoon to a publisher, you are rarely selling the actual cartoon itself as a piece of tangible property. Most often what you are selling is the right to publish your work in a particular publication. This means you are giving the publisher permission to print your cartoon in the magazine, while you retain ownership of both the original art and its copyright. If you sell all rights to a cartoon, you are relinquishing your interest in the work and assigning your entire copyright to the buyer.

When a magazine specifies that they are buying first rights to a particular cartoon, it means that they are paying you for the right to be the first magazine to publish that cartoon. No other publisher may be given permission to reprint that cartoon until after the first publisher has printed it. It is quite common for magazines to buy first rights to cartoons, especially those magazines that offer higher payment rates for this privilege.

When a magazine buys one-time rights to a cartoon, it means that they are paying you for permission to publish your cartoon one time in their magazine with no other restrictions placed on future publication of the work by other magazines. In other words, you can resell this same cartoon to another magazine right away. To protect your good relationship with your editors, however, you should be careful not to sell the same cartoon to directly competing magazines, such as *Good Housekeeping* and *Woman's World*, that share similar and overlapping readerships.

Cartoonist and greeting card creator Rick Stromoski has been very vocal about the issue of reselling cartoons several times through multiple submissions. "I resell my cartoons to as many magazines with an editorial slant consistent with a particular cartoon as possible. I never sell all rights to a cartoon because you may have an extremely funny idea that can be sold in many different ways (to magazines, book publishers, greeting card companies and so on). Cartooning is a business—a fun way to make a living, but a business nonetheless." Stromoski also believes that magazine cartoonists often face unfair restrictions, compared to other artists. "Is the latest Whitney Houston song only played on one radio station? Can Rodney Dangerfield never tell the same joke in a different club? Does the fact that a cartoon has been published before make it any less funny?"

Should I send copies of my cartoons to more than one magazine at a time?

In the beginning, it's best to send your submissions to one magazine at a time. After one magazine has returned your material, you can then send it to the next magazine on your submission list. Eventually, each cartoon batch will go to several different publications, and hopefully you'll log a few sales along the way. Before you acquire a solid understanding of the magazine cartoon marketplace, you might accidentally violate an editor's specific rights to your work by reselling a cartoon improperly. As you be-

Cartoonist Profile:
ED KOEHLER

In addition to his freelance cartoon and illustration work, Ed Koehler has had two cartoon anthologies published by InterVarsity Press. Both books, *Amusing Grace* and *As The Church Turns*, came about as a result of Koehler's many cartoon sales to a variety of Christian-oriented magazines such as *Today's Christian Woman, Campus Life, Wellspring, Marriage Partnership* and *Your Church.* While Koehler admits he is not a household name in the cartooning field, he has become very well known by many editors and publishers of religious materials. After establishing a name for himself in the world of Christian publishing, Koehler used his reputation (and a batch of 20 sample cartoons) to secure his first book deal. His second book of cartoons came more easily, after the first book proved to be a success.

When it's time to write new gag ideas, Ed Koehler appreciates the peace and quiet of the local library. He spends his time searching

"Good evening, my name is Michael, and I'll be your waiter, but I won't be in your way."

through news magazines and other publications, looking for everyday events, fads and topics which he focuses on and relates to Christian life in a humorous way. Like many great cartoonists, Ed does his best writing in the morning when his energy and alertness are highest.

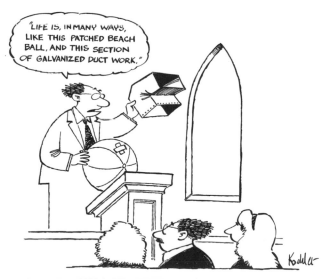

Pastor Updike's sermon illustrations were creative, if somewhat oblique.

come more aware of what magazines buy what kind of rights, you can begin to develop a more complicated marketing plan that involves simultaneous multiple submissions. This kind of marketing savvy will come to you with time and experience.

I often see entire books filled with magazine-style panel cartoons based on one central theme, such as cats or doctors or mothers or babies or sports. How can I get my gag cartoons published in book form?

Magazine cartoons aren't just for magazines anymore! Many publishers have found a strong audience for gag cartoon books and most book stores have several on their shelves. Well-known magazine cartoonists, such as those from the pages of *The New Yorker* or *Playboy*, have an established following of fans, and book editors come to them with publishing offers regularly. On the other hand, if you're not so well known, it's up to you to approach book publishers with proposals for your work in book form.

To get a book of your cartoons published, first establish a central theme for your collection. Your theme might be cats, dogs, parenthood, cars, football, fishing, religion, or whatever you think the public would be interested in buying. Next, create at least 20 strong audition cartoons, submit photocopies to a cartoon-book publisher and hope for the best. Include a brief cover note with your submission, explaining the theme of the book and who you have identified as your target audience. If you have established any sort of successful track record as a cartoonist, be sure to mention that in your letter as well. Remember to include a self-addressed, stamped envelope for the return of your material if it is not accepted for publication. If your book is accepted, be ready to create one hundred or more thematic cartoons, enough to fill up an entire book.

This same method may be used to sell a publisher a cartoon calendar of your work. A monthly wall calendar would require only twelve strong ideas, but would probably depend on your ability to work well in color. A weekly desk calendar would require you to create fifty-two cartoons on a theme. If you want to create a cartoon-a-day calendar, you must be able to convince a publisher that you're capable of writing and drawing 365 high-quality cartoons based on a specific theme.

For more information about book and calendar publishers, study the books and calendars you find for sale in different shops and consult *Artist's Market*, *Writer's Market* and *Humor and Cartoon Markets* for addresses and other information.

Ever since I began drawing, it's been my dream to have my own syndicated newspaper comic strip. What's the best way to achieve this goal and what are my chances for success?

Today there are fewer newspapers than in the past. Years ago almost every city had two or more competing newspapers, and hot new comic strips were used by editors to steal readers away from the competition. Since many cities now have only one

Cartoonist Profile:
GREG EVANS

The cartooning bug bit Greg Evans early in life and his many years of perseverance and hard work paid off when his comic strip *Luann* became a big hit with newspaper readers all over the world. "I began submitting comic strip ideas when I was in college in 1970," Greg recalls, "and I continued off and on until *Luann* hit in 1985. So you can see what an overnight success I was. It's always disappointing to get yet another syndicate rejection, and I certainly had my share. More than once I vowed to throw away all my pens and get on with real life. But anyone who carries the cartoon virus will tell you that you can't get rid of it. It's a lifelong affliction. The key to happiness in this business is to not think of syndication as the 'cure' but only as one of the many ways to scratch the cartoon itch. Realize that happiness can also be found in reaching lots of smaller goals (not just reaching one large goal).

"I have yet to find a magic tool that will turn on the creative tap," admits Evans. If anyone else does, could you please let me know? I have found that I do better standing and pacing than sitting, mainly because I'm less likely to get lazy." Actually, Evans often finds that creative thinking induces drowsiness, although he has no idea why. His strategy, then, is to begin each day's writing session with a nap. "I nap 15 or 20 minutes at most, then I write. Is this a great occupation or what? I mean, what other jobs require napping as part of the daily work?

"As for training, I always suggest a solid college education, as much for the general knowledge you get as for any art training. I believe that to be witty, you must be somewhat smart or at least well educated. Being a good artist isn't enough in the world of professional cartooning—you must also be clever. And the more you know, the more you have to tap into. I enjoy the challenge of trying to make *Luann* better every day. This is what keeps it interesting and keeps me going year after year."

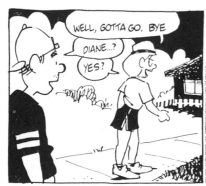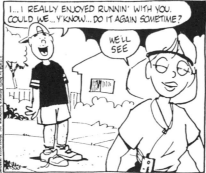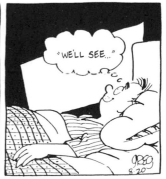

Reprinted with special permission of North American Syndicate.

daily and Sunday newspaper, the market for comic strips and panels has become much smaller and many papers pay less for strips now than in the past. Many cartoonists fear that it may not be long until every newspaper publishes virtually the exact same comics as every other paper, thus destroying much of the field's creative diversity and opportunities for new cartoonists.

Long before every home had access to fifty or more cable TV channels, newspaper comics were a much more significant source of entertainment. Nonetheless, newspaper comic strips and panels still entertain millions of fans everyday. Great new comics debut each year, and a few overcome the odds and encounter lasting success and popularity. This success is often made even greater when popular strips are reprinted in book collections or licensed for use in advertising, greeting cards, on-line computer services, merchandising and animation.

There is no guarantee that you will ever get rich in syndication, but you may be able to earn enough to support yourself and a family. Far more important than the money, however, is the satisfaction that comes from being creative and doing what you love for a living, instead of punching someone else's time clock and working under someone else's rules.

If you're interested in becoming syndicated and having your cartoons appear in newspapers all over the world, it's best to just concentrate on doing great work . . . if you do that, the money will take care of itself.

If you want to get your own cartoons syndicated, there's only one thing you must do: Try! Daydreaming won't make it happen. Talking about

it won't make it happen. Wishing won't make it happen. If you want to get syndicated, you've got to turn off the television and get to work. Here are the step-by-step basics of preparing a comic strip or panel for syndication.

Step 1. Create a cast of characters. Before you begin to write funny ideas, create your characters. Your ideas should be created to fit your characters—your characters should not be created to fit your ideas! There is no surefire way to create classic cartoon characters. Just study the world around you and write about the type of people you know best. Remember: A great character is based on a personality, not an occupation or location. (If your character works in a cafeteria, she should be just as funny if she worked at a bank or a daycare center.) Study your favorite strips and try to determine why you enjoy reading about the characters. Try to create fully developed, funny characters that readers will be interested in and amused by. It's also a good idea to create characters that readers can relate to. Readers like to read about themselves.

Step 2. Write several comic strip gags. Follow the format you see in the newspaper strips. Break your dialogue into 1-, 2-, 3- or 4-panel boxes. Make sure your ideas are concise and easy to read. Your ideas should be entertaining, not confusing. Keep your gags faithful to your characters' individual personalities. Don't force a gag if it's out of character. If your main character is an unemployed teenager, for example, don't force him into a gag about buying an expensive car just because you happened to think up a funny gag about expensive cars. Always strive to have your gags come

NIFFY

AGGIE GREG ALBERT

If you want to create the world's next great comic strip, the first thing you must do is create an interesting cast of characters. A great comic strip character should be based on a personality, not an occupation or a location. Your character's personality should make him or her funny in any setting or situation. Most great comic strip characters are autobiographical to some degree; that is, they have personalities which are usually quite similar to their creators and their creators' friends and families.

from a place within your characters.

Step 3. After you've written several great gags, select only the very best ones to draw. Cut a piece of bristol board (or any other paper you're comfortable with) to fit the necessary dimensions of the comic strip format. Your actual art should be two or three times larger than the comics published in the newspapers. If a published strip is 6″ wide and 2″ tall, then your original art should be 12″ wide and 4″ tall or 18″ wide and 6″ tall.

Step 4. Lay out your borders, rule your lettering guide, and sketch your drawings. All of this should be done in pencil, using any of the methods discussed in the section on magazine cartoons. As you create your layout, be sure your characters' dialogue flows smoothly from left to right. Also try to make your strip interesting to look at by creating different camera angles from panel to panel.

Step 5. Ink your borders, lettering,

characters and backgrounds. After the ink is completely dry, erase any pencil lines. Sign your work. Pat yourself on the back. Go get a Pepsi. Then get back to work. You need to draw at least eighteen finished comic strips before you make your presentation to the syndicate editors.

Step 6. After you have at least three weeks' worth of material finished, make photocopies to mail to the syndicate editors. You may submit to all of the major syndicates simultaneously. This is a common practice and you may be fortunate to receive competing offers from more than one syndicate. Be sure to put your name and phone number on each drawing and include a large postage-paid envelope for the return of any rejected material. You can find a complete list of syndicate names and addresses in *Artist's & Graphic Designer's Market* or *Writer's Market.*

Step 7. If your strip attracts some

interest from a syndicate, you may receive a development contract. This contract pays a nice fee, generally around $2,000 to $4,000, and obligates you to a particular syndicate while they help you further develop your work, polishing and perfecting it for eventual syndication to newspapers. At the end of the contract the syndicate will decide whether or not to formally accept your concept and continue the relationship.

Step 8. If your work is rejected immediately or if a development deal eventually goes sour, congratulate yourself on being normal. Even the greatest and most successful cartoonists were rejected many times before finding their way into the hearts of millions of readers worldwide. A few cartoonists succeed with their very first comic strip effort, but most try and fail many times before achieving success. Neither success nor failure can be accurately predicted at the beginning of your journey. *If you try, you may succeed—if you never try, you are guaranteed to fail.*

During this entire process, you'd be wise to give some thought to marketing matters. Does your strip fill a need in the marketplace? (This is the key question one must ask when creating *any* new product, whether the product is a new comic strip or a new style of athletic shoes or a new breakfast cereal.) Is there a significant segment of the population that's being overlooked on the comics page? Contemporary working women, for example, were largely overlooked on the comics page before *Cathy* and *Sally Forth* were created to fill that gap.

While you're busy creating the world's next great comic strip, continue to study the comics in your local newspapers. Never stop learning and growing. Because your local newspaper may publish only a limited number of comics, consider subscribing to *The Nation Forum STRIPS*. Every weekly issue of *STRIPS* brings you over four hundred brand new cartoons from more than sixty of today's hottest new comics and popular classics. In *STRIPS* you'll find plenty of mainstream syndicated comics that don't appear in your local paper, and you may be introduced to some exciting new techniques, styles and influences. There are still plenty of comics that *STRIPS* does not carry, so don't cancel your local newspaper subscription. Continue to read a good newspaper every day for comics, articles and world events, but for an extra blast of brain food, supplement your reading with a subscription to *The National Forum STRIPS* (Associated Features Inc, PO Box 7099, Fairfax Station, VA 22309).

To learn more about great comic strip creators and their creations, read the book *Calvin & Hobbes, Garfield, Bloom County, Doonesbury and All That Funny Stuff* by James Van Hise, published by Pioneer Books Inc., 5715 N. Balsam Road, Las Vegas, NV 89130. This book will give you insights into the careers of fourteen unusually popular cartoonists and what they went through to achieve their high degree of success. Included in this book are articles and interviews with many cutting-edge creators, including Berke Breathed (*Outland*), Bill Watterson (*Calvin & Hobbes*), Garry Trudeau (*Doonesbury*), Gary Larson (*The Far Side*), Matt Groening (*Life In Hell*), Gahan Wilson (*Nuts*), and Buddy Hickerson (*The Quigmans*).

After you've created your characters and some good gag ideas, lay out your comic strip in pencil on a sheet of bristol board (or any other paper you're comfortable working with). Most comic strips use two, three or four panels to communicate each gag.

Use a ruler to create a guide for your lettering, paying close attention to the spacing of your lines. Pencil in your lettering. Many professionals now print their personal comic lettering with a computer and laser printer, but some feel this looks too mechanical and unnatural, and prefer to do it the old-fashioned way, by hand.

Next pencil in your characters, props and backgrounds.

When all of your pencil work is done to your satisfaction, ink your strip with an artist's pen, brush or felt-tip marker. When the ink is completely dry, erase all pencil lines. Now start all over again . . . and again . . . and again . . . you'll need at least eighteen comic strip samples if you plan to make a presentation to a newspaper syndicate.

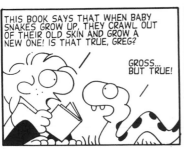

If I am lucky enough to get a syndicate contract, what sort of deal should I expect**?**

Each syndicate has its own basic contract for cartoonists, and the terms differ somewhat from syndicate to syndicate. In the most basic terms, a syndicate agrees to attempt to sell your work to newspapers and you agree to provide them with your best work and meet your deadlines on time. Revenues are generally split fifty-fifty between the cartoonist and the syndicate. Syndicate contracts are lengthy documents full of legal details, many of which are negotiable.

When negotiating a syndication contract, you should most definitely insist on owning the copyright to your work. In years past, syndicates used their power and influence to obtain complete ownership of a cartoonist's creation, but fortunately this unfair situation rarely happens anymore. Controlling your copyright prevents you from being owned by a syndicate and gives you the freedom to renegotiate your contract or change syndicates if you feel your work is not being managed properly.

Of course, you should review your syndicate contract with an attorney. Unfortunately, most lawyers have very little experience with cartoonist or syndicate matters and may not be of much help. An attorney with experience in the literary field may be a wiser choice than your average all-purpose lawyer, but may be expensive and difficult to locate. Your best bet is to accept your own lawyer's advice for what it's worth, but also watch out for yourself and make sure you are agreeing to terms *you* can live with for the life of your strip.

I don't like the idea of being tied down to just one form of cartooning and devoting myself to the same characters for the rest of my life. I'd like to get involved in a lot of different cartoon projects like children's books, calendars, greeting cards and T-shirts. Where can I find companies who buy this kind of art and how can I get them to buy my work**?**

The type of work you're describing is known as *humorous illustration*. As pointed out earlier, there is a difference between a cartoonist and a humorous illustrator, although both can accurately be called comic artists. A cartoonist creates both words and pictures to communicate a funny idea, but a humorous illustrator creates pictures only to accompany someone else's text (such as a magazine article, children's book, advertising copy or greeting card sentiment). A humorous illustrator usually creates work on assignment and takes his direction from an editor or art director. More and more freelancers are developing well-rounded careers which incorporate both cartooning and humorous illustration into their schedules.

To sell your work as a humorous illustrator, you must have an attractive or engaging comic art style that will capture the attention of editors and art directors. To get your work noticed by potential clients, you must learn how to advertise and promote your services effectively. As an illustrator, you are not just selling your art as a product, you are also selling your time, talent and skills as a service. To stay in business and keep clients coming back for more, you must be able to follow directions, work well

Cartoonist Profile:
BILL HOLBROOK

Getting a comic strip syndicated is a great accomplishment. Bill Holbrook has done it *twice*—he is the creator of two successful strips, *On The Fastrack* and *Safe Havens*. "*On The Fastrack* is certainly autobiographical," Holbrook explains. "It is set at a company overrun with office politics, backbiting, backstabbing and gossip, which definitely describes a newspaper where I used to work. In two and a half years, I got enough material to last a lifetime. *Safe Havens* is gentler, and more of the humor comes from my young daughters.

"I try to keep both strips fresh by having the characters respond to current events and occasionally bringing in new characters. When I write, I put on a CD, usually classical music since it's important that there are no words to distract the thought process. I read *The National Forum STRIPS* to get my mind into the rhythm of comic strips, and then I just see what happens. To create enough funny material for two strips, I write about 20 to 24 ideas and then whittle that down to 14 usable ideas.

"As far as training goes, I have a B.A. in illustration and visual design from Auburn University. Just as important, though, I was an art director of the student newspaper and had four or five drawings printed every week. That experience led to a position as a staff artist at the *Atlanta Constitution*, where I honed my style.

"From the time I was in elementary school, this is what I wanted to do, and I've single-mindedly pursued it ever since. That attitude helped me get over a lot of rejections along the way."

With special permission of King Features Syndicate.

with others, and meet even the tightest of deadlines. The humorous-illustration field is fiercely competitive and you'll need to do quite a bit of self-promotion to keep assignments flowing into your studio on a steady basis.

To advertise your services as a humorous illustrator, you'll have to spend a few hundred dollars to get started properly. To begin, you'll need to have some samples of your work printed on flyers or postcards to distribute to potential new customers. Color samples are always best, but black-and-white will do if your budget is restricted. Consult your telephone directory to find a good commercial printer to print your samples. In the pages of *The Artist's Magazine* you can find advertisements for some outstanding printers who specialize in printing accurate and attractive color samples especially for artists.

Your printed samples should feature a representative piece of your work, or several pieces on a page, plus your name, phone number, and a list of any impressive clients you have worked for. Put your postcards or flyers into envelopes to protect them from being marked up by machines at the Post Office, then mail them to as many potential customers as you can afford. If you own a computer, you can save yourself a great deal of work by creating a database for your mailing list and using your printer to automatically print labels for each of your mailings. Your database can easily be updated and expanded as you begin to make contacts and discover new potential clients. To get started promoting your work, you can find all the addresses you need in *Artist's & Graphic Designer's Market* or *Writer's*

Market. Later, when you're ready to invest in a more extensive mailing, you can purchase accurate mailing lists from companies such as American Business Information (P.O. Box 27347, Omaha, NE 68127) or Creative Access (415 West Superior, Chicago, IL 60610).

Creative talent directories are another popular way to advertise your services as a humorous illustrator. These large talent books are delivered to thousands of art directors and art buyers all over the world and feature samples from hundreds of the world's best humorous and non-humorous illustrators. Advertising your work in one of these directories can be very rough on your bank account, with page rates starting at approximately $2,000 and often going hundreds and even thousands of dollars higher.

Unfortunately, buying a page in a talent directory does not guarantee that you'll get any assignments. Investing in talent directories is usually a gamble. Some pages pay off with many thousands of dollars in new assignments, other pages bring in absolutely no work at all. Your success in a talent directory will depend on the popularity and quality of your work, the suitability of your style for certain jobs, the needs of the clients, how often buyers take the directory off the shelf and refer to it, the economy and a variety of miscellaneous factors. By and large, talent directories have gotten some wonderful results for many humorous illustrators and may certainly be worth the investment when you're ready to give them a try. Despite some shortcomings, they are still the best way for your work to reach a potential market of 20,000 or more

"No, Jimmy, the Tooth Fairy won't be visiting you anymore. I'm the Pimple Fairy."

buyers.

For more information on the best-known creative talent directories contsult the *American Showcase, Creative Black Book, Graphic Artist Guild Directory of Illustration*, and *RSVP Directory of Illustration & Design.*

If your budget doesn't allow printing or expensive advertising of any sort, then your best alternative is to prepare a neat portfolio of your work and show it in person to publishers and advertising agencies in your area. Buy an attractive portfolio case at an art supply store, fill it with your best work, make some appointments, and present yourself as professionally as possible. After you've landed a few assignments this way, invest your money in some printed samples so you can begin to contact a greater number of potential clients through the mail.

Regardless of how you approach potential clients, always be as professional as possible. All of your correspondence should be attractive and businesslike, printed on a quality ink jet or laser printer or typed on professional stationery. Your presentations should be neat and clean, and your personal conduct should always be polite and friendly. For more information, consult *Creative Self-Promotion on a Limited Budget* by Sally Prince Davis and *Getting Started as a Free-lance Illustrator or Designer* by Michael Fleishman. Both books are published by North Light Books.

Illustrator Profile:
DARYLL COLLINS

Daryll Collins doesn't draw magazine cartoons and he doesn't have a syndicated comic strip but he's one of the busiest comic artists in the business. Collins is a successful freelance humorous illustrator, whose clients include *Sports Illustrated For Kids*, Hallmark Cards, Proctor & Gamble, and Kellogg's.

"I guess I kind of fell into humorous illustration," says Collins. "I wanted to get my foot in the door somewhere to work as a cartoonist on a full-time basis. When I graduated, the animation industry was in a downswing, the chances of getting a comic strip syndicated were slim at best, and the spots for an editorial cartoonist on a newspaper staff are limited. The greeting card industry seemed like a good option, as they seemed to use a large amount of humorous illustration. As an employee at Gibson Greetings I got to develop my cartooning skills, work in color, and learn from a talented and experienced staff of artists."

During his stint as a staff artist for Gibson Greetings, Daryll dreamed of being his own boss and freelancing from his own studio. Actually, he did much more than dream; he planned for his future, saved his money for three years, and was fully prepared to open his own studio the day he left Gibson. "By the time I left my day job," he recalls, "I had paid for a page in a talent directory, I owned a fax machine, and I had enough money put away in the bank to get me by until my own business got going. Gibson continued to send me freelance work, and that was a big help." Even as a successful illustrator, Collins believes that frugality and planning are essential skills for any freelancer. "Your income is always going to fluctuate from month to month or year to year, so you can't take anything for granted.

"What I like best is the freedom to set my own schedule and to work on a variety of different projects. One day I may do a greeting card, the next day an illustration for a magazine or maybe a T-shirt design. What I like least are the tasks other than illustrating that you have to do when you're running your own studio. There's promoting your work to potential customers, bookkeeping, purchasing supplies, meeting with and delivering jobs to local clients and packaging and mailing your artwork to out of town clients. There's a lot more to it than sitting around sketching all day.

"Humorous illustration is a specialized skill within the art field. You've got to have a sense of humor because that's what the art director is asking you to bring to the assignment. You've got to have the ability to interpret editorial content, a sales pitch or a greeting card in a visually humorous way. You've got to have an understanding of what characters, situations and expressions are likely to bring a chuckle from the viewer of your work.

"For my ink line work, I use Gilliott #170, Speedball A5 and B6, Hunt EF513 pen nibs, or a Winsor & Newton series 7 no. 2 brush. Occasionally I'll use technical pens or even markers for finished line work. Since most of my work is in color, I render my line work on an overlay of Denril vellum and my color on two-ply cold press bristol or Badger airbrush board. I use a Thayer & Chandler Model A airbrush. The paint I use is Winsor & Newton gouache or Dr. Martin's dyes. I found, through trial and error, that these materials work best for me. It's only through experimentation that you'll find what is the most comfortable and what tools give you the desired results. I'm currently learning to work with some of the paint programs available

for the computer. Eventually I'd like to incorporate it as another tool I use to create illustrations. Of course, the computer is not a substitute for the artist, it's only a tool.

"It's important to be observant. Be an information sponge. Pay attention to people's behavior, interests and mannerisms. Keep abreast of trends in popular culture and listen to what people are talking about. Try to know a little bit about everything. You never know when you can apply this information to a humorous illustration job. Cultivate good work habits. Be dependable. There are very few overnight sensations in the humorous illustration field. If it's what you want, go for it!"

© Daryll Collins.

Can any cartoonist call himself a humorous illustrator or does this specialty require certain training or equipment that an ordinary cartoonist might not have?

Any cartoonist can call himself a humorous illustrator, but saying it and being it are not necessarily the same thing. A cartoonist may not be able to draw well, but can still make plenty of sales based on the strength of his gags. A humorous illustrator, on the other hand, must have great artwork and the ability to communicate humorous concepts without words.

Another vital skill for the humorous illustrator is the ability to use color effectively. For most illustrators, 80 percent or more of their work is done in full color. If you're a cartoonist doing the majority of your work in black-and-white, you must learn how to do great color art if you're going to convince clients that you're a humorous illustrator. You can learn how to create comic art in color by getting an art school education, attending weekly classes, or by practicing at home with a little help from some good art instruction books.

If you decide to advertise yourself as a humorous illustrator, make sure you have the time and energy to meet your clients' needs. If you're working a full-time day job and freelancing on nights and weekends, you may not be able to satisfy a client who needs twelve color illustrations delivered to her in forty-eight hours. However, if you're more selective about who you approach for work, you can probably squeeze in some assignments in your spare time.

Once you begin to include humorous illustration in your cartooning ca-reer, you probably won't go far without investing in a good, reliable fax machine. When editors and art directors want illustration, they usually need it fast. They need to send you their assignments fast and they need to receive your roughs fast. Since time travel machines haven't been invented yet, you'll have to buy a fax machine. Keep your studio phone and fax on a separate number from your home phone. Clients cannot call you with assignments if your phone is being used endlessly by your spouse and children. (Call-Waiting is not the best solution to this problem, since it is bad business to interrupt a client while you take another call from a friend, relative or telemarketer.)

Humorous illustration is a legitimate small business, and like any small business, there will be some initial startup expenses. The cost of your fax, answering machine, some basic art materials, office supplies and a few hundred printed samples of your work will probably add up to a thousand dollars (or less). This may sound like a great deal of money, but there are very few small businesses that can be launched with such a modest investment.

How can I sell my work to greeting card companies? Can I just sell my art or do I have to write the ideas, too?

There are a variety of ways to enter the greeting card field. Greeting card publishers are always hungry for exciting new writing and artwork from talented, creative people. If your work is very good and well-suited for the greeting card business, you will find

Cartoonist Profile:
JOE KOHL

Many cartoonists include humorous illustration as one element of a multi-faceted career. Joe Kohl creates gag cartoons for magazines, does color illustrations for many different publications and advertising agencies, creates comic designs for T-shirts and beer mugs, writes and draws greeting cards, and is the author of two cartoon collections, *Marital Bliss and Other Oxymorons* and *Unspeakably Rotten Cartoons*.

Balancing many different projects keeps Kohl very busy, and self-promotion is a constant, ongoing process. "I make up flyers with samples of my art and send them out. Greeting cards I submit to the companies the same way I would cartoons. I have a licensing agent for mugs, books and T-shirts. Illustration work (books, advertising and magazine illustration) is largely the result of my promotional flyers.

I've had little luck with source books and talent directories.

"Time is no problem. Sometimes I'll just do greeting cards for weeks at a time. Then I'll switch to magazine cartoons for a while. When I get an illustration job I set aside all the speculative stuff and tackle the job. Sometimes I look through my old cartoons (sold and unsold) and try to put a new slant on them or adapt them for greeting cards or T-shirts.

"The best part about freelancing is the autonomy. I have no bosses, no time-clocks to punch, no dress code and no deadlines (except for illustration jobs). The worst part about freelancing is no perks, no medical insurance, no salary, no unemployment coverage, no minimum guaranteed income, no pension plan, nobody to talk to, and I always get stuck with all the leftover potato salad at my company picnic."

"I left a message on your machine."

© 1994 Joe Kohl.

that your services will be readily welcomed and in demand.

For full-time employment at a greeting card company, send your résumé to the Director Of Creative Recruitment along with a portfolio of your work. Major card companies, such as Hallmark Cards in Kansas City, Missouri, recruit much of their new talent from the best art schools in the country.

To find employment as a staff artist, your work must be of the highest quality and should show a strong degree of versatility to indicate that you are able to work on many different types of projects. The ability to create great color work is particularly important. Some solid experience in computer graphics is also a big plus, because more and more designs and layouts are being created or composed electronically.

If your résumé and samples make a strong impression, you may be called in for an interview to discuss possible employment. As a cartoonist (that is, a creative person who can write funny *and* draw funny), you may be surprised to find yourself hired as a humor writer instead of an artist, but good writers are harder to find than good artists. Large greeting card companies are swarming with talented people and the atmosphere is supercharged with creative energy, making this a great place to build your career.

Freelancers may find work in the greeting card industry as humorous illustrators. When you send your postcard illustration samples to prospective buyers, be sure to include several greeting card companies on your mailing list. Many card companies have small art staffs and rely heavily on talented freelancers. Because of the high volume of work they publish, greeting card companies can become some of your best repeat customers.

Many cartoonists, including Rick Stromoski and Joe Kohl, create both funny text and art for greeting card companies and mail batches of rough layouts using the same submission methods they use for their magazine cartoons. They are paid extra for creating the entire greeting card, from initial idea to finished art, and often receive royalty payments as well. If you're sending greeting card roughs to a company that is not yet familiar with your work, be sure to include a finished sample of your work with your submission.

For detailed information on this specialized field, read *The Complete Guide to Greeting Card Design and Illustration* by Eva Szela and *How To Write and Sell Greeting Cards, Bumper Stickers, T-Shirts and Other Fun Stuff* by Molly Wigand (F&W Publications, 1507 Dana Avenue, Cincinnati, OH 45207).

What's the best way to find work as a comic book cartoonist? Also, is there room for humorous art in the comic book field or is it strictly realistic superhero stuff now**?**

Yes, there is plenty of humorous art being used in comic books. While most feature dynamic superheroes, there is still plenty of work for humorous artists who are able to render popular TV characters such as *Ren and Stimpy, Tiny Toons, Beavis and Butthead* or *The Simpsons*.

Creative Director Profile:
LINDA KING

Linda King is the former Creative Director for Paramount Cards, a prolific greeting card publisher that hires many freelancers. She has since left for a position at a different company and has plenty of advice for anyone hoping to be a staff artist or a freelancer.

"A good portfolio consists of a clean, professional presentation of pieces that best represent your art style. Don't make the mistake of padding your portfolio with borderline pieces— they only weaken it. A few really strong pieces is better. The samples should not be originals. Use color copies, slides or printed samples. Explain which samples should be returned and which may be kept on file.

"Most cartoonists, for reasons unknown to me, are guys. And most guys do not buy and send greeting cards. Ninety percent of greeting cards are bought by women. All the card companies know this, and it's a big determining factor in what we publish. So whether you are a man or a woman, I suggest you ask your female friends if they would buy your work and send it as a greeting card. And if not, why? You may get some surprising and helpful criticism.

"I don't mean to be jaded or sarcastic, but every artist on the planet thinks they have a unique and original style. In general, there is room for both the tried and true as well as unique approaches, as long as the artist can differentiate between what is traditional and what is dated, and between what's unique and what's just too damned weird. In the alterntive art area, I do look for fresh, offbeat and original styles.

"A great humorous greeting card is, well, funny. And sendable. It should be more than just a joke. The card should have a real 'me to you' message between sender and recipient. The more sendable it is, the greater it is."

Inside: And back into our lives where it belongs. Happy Birthday!

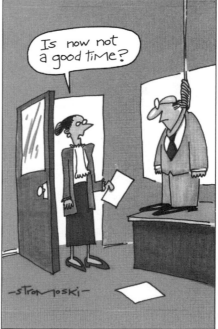

Inside: Hang in there.

As with other forms of humorous illustration, the best way to find employment in this market is to show samples of your work to the right people. If you want to receive illustration assignments from comic book publishers, create and submit a sample comic book page using the publisher's established characters or characters of your own. If the art directors and editors approve of your work, you may be asked to pencil or ink additional samples before receiving your first assignment. Payment for comic book art is made on a per-page basis, with beginners earning less than established pros. To earn a living drawing comic books, you must learn how to draw fast and be able to finish several pages of work in a relatively short amount of time. There are many books which discuss comic book art in detail, including *How To Draw and Sell Comic Strips* by Alan McKenzie (North Light Books).

I've always been fascinated by animated cartoons and would like to make this my career. How can I learn to be an animator and get a job with a good animation company?

Dave Schwartz, Development Art Director for Disney Animation and a graduate of the Kubert School, recommends a solid art school education as the primary training you'll need for a career in the animation field. A well-rounded education is important because a career in animation may find you creating storyboards, designing characters or backgrounds, working on a computer, even writing stories and dialogue. "Nothing is wasted, ed-ucationwise," says Schwartz, "it all comes into play eventually." A strong portfolio is a must to get started, and once employed you will continue to gain experience in-house.

According to the Animators Union in Los Angeles, California, some of the more popular animation schools include The Ringling School in Sarasota, Florida, and California Institute of the Arts in Valencia, California. Great animation schools can be found all over the world, however, and a list may be obtained by contacting The International Animated Film Society in Burbank, California.

To learn more about animation right away, read *Film Animation Techniques: A Beginners Guide and Handbook* by Lafe Locke, published by Betterway Books. This book covers the basics of animation and explains in detail how you can get started in a career in animation. Also highly recommended are the books *The Illusion of Life* and *Too Funny For Words* by veteran Disney animators Frank Thomas and Ollie Johnson (Abbeville Books). A good book store will also carry several outstanding books stuffed full of information on the art and business of animation.

Can cartoonists do children's books or do the publishers only want art that is fancier, more detailed and more sophisticated?

Yes, cartoonists can do children's books. Many humorous illustrators and cartoonists have enjoyed great success in the children's book market. Successful children's book illustrators who are also cartoonists include Roger Bollen, creator of the

Greeting Card Artist Profile:
PAT SANDY

Pat Sandy is a staff writer and artist for American Greetings in Cleveland, Ohio. Pat gets to indulge his passion for thinking, writing and drawing funny ideas; he gets to work in a creative environment surrounded by other funny people; and, unlike freelancers, he enjoys the benefits and perks of full-time employment.

Pat stresses the importance of understanding the difference between a cartoon and a greeting card. "With cards you're often dealing with a 'me to you' sending situation (For Your Birthday or On Your Anniversary). So that's a bit different from strips or magazine cartoons. On the other hand, the classic structure for greeting cards, with a page 1 setup and a page 3 punchline is similar to a comic strip.

"While there are exceptions, if you're a cartoonist and you want to be on staff, you have to be able to render your work in a variety of techniques or styles, with an eye toward keeping up with industry trends. In this sense, you would be more of a humorous illustrator. This often applies to freelance work as well. However, if you're marketing one look as a freelancer, it ought to be something your potential buyer doesn't already have on staff.

"Also, it can help if your skills include gag writing. Good writers/artists are difficult to find and very employable, whether on staff or freelance. I like to write or conceive ideas in the morning, fueled by tons-o-coffee. Usually, I'll start doodling or writing phrases or whatever; doing it at the same time every day helps.

"As a kid, I spent a lot of time reading comic strips, comic books and *Mad* magazine. I liked trying to draw characters like Snoopy or Beetle Bailey, and I was fascinated by the vocabulary of cartooning (the Big Foot style, motion lines and sweat marks). Without realizing it at the

time, I was studying the masters! I doodled my way through high school and earned a B.F.A. in graphic design from the University of Akron. In college I had the opportunity to do four editorial cartoons a week for the school paper and one a week for a suburban paper. This was great experience; not only was I writing and drawing on a regular basis, I was learning to function creatively under a deadline.

"My first break was seeing my work printed in the college paper. It was a real thrill and it inspired me to keep going. My big break would have to be coming to American Greetings. It's a very creative atmosphere to be in and you can't help but improve your work."

He's making a list,
He's checking it twice...

Reprinted with permission © AGC, Inc.

Inside: Santa sounds a little obsessive-compulsive to me.

syndicated comic strip *Animal Crackers*; Gahan Wilson, famous cartoonist for *The New Yorker* and *Playboy* magazine; Jared Lee, who got his start in greeting cards and magazine cartoons; Dik Browne and Mort Walker, creators of *Hagar the Horrible* and *Beetle Bailey*; Jerry Dumas, creator of *Sam & Silo* and longtime collaborator on *Beetle Bailey*; *Doonesbury* cartoonist Garry Trudeau; and Stan and Jan Berenstein, whose non-bear cartoons have appeared in *Good Housekeeping* for many years. Several famous cartoonists from *The New Yorker* have also enjoyed success in children's books, including Syd Hoff, James Stevenson, Mort Gerberg and George Booth. While children's book legends Dr. Seuss, Shel Silverstein and Maurice Sendak are not necessarily classified as cartoonists, their drawing styles are undeniably cartoony.

If a cartoonist or humorous illustrator wants to branch out into children's books, the simplest route is to include several publishers in your periodic promotional mailings. Send your postcards and flyers to as many children's book editors and art directors as possible. If your style is appealing and suitable, you may be asked to submit a more extensive portfolio while being considered for a children's book illustration assignment. An alternative route is to create an entire book, story and art, to submit to publishers as a package.

For more information, read *The Children's Picture Book—How To Write It, How To Sell It* by Ellen E.M. Roberts and *Writing For Children and Teenagers* by Lee Wyndham and Arnold Madison. Both titles are available from Writer's Digest Books.

While practicing my cartooning, I've gotten pretty good at drawing cartoons that look like famous people, movie and TV stars, politicians and other celebrities. How can I earn some money or even start up a career doing caricatures?

The quickest and perhaps easiest way to earn money with your caricature talent is to tap into your local marketplace. Advertise your services in the newspaper, on bulletin boards or in the phone book, and begin to make your services available for birthday parties, fund raisers and so forth. Once you've determined your hourly fee, you can earn plenty of extra cash drawing caricatures of party guests, students and other local folks for a few hours on an evening or weekend.

Your local newspaper may be another good outlet for your caricature talents. Put together a portfolio of your best work and try to include caricatures of some local politicians and celebrities. This presentation may land you some freelance illustration assignments now and then or could even result in full-time employment as a newspaper staff artist. This success could become your stepping-stone to bigger and better things, perhaps a promotion to a larger or more prestigious newspaper or even national syndication of your political cartoons. To become aware of employment opportunities in newspaper cartooning, subscribe to *Editor and Publisher*, 11 West 19th Street, New York, NY 10011.

Another way to find work as a caricature artist is to promote yourself as a humorous illustrator who specializes in caricatures. Your self-promotion

Dear Shagg,
What is the biggest animal that a boa constrictor can swallow?

LYNN JOHNSTON
CORBEIL, ON

ACCORDING TO MY RECORDS, THE BIGGEST ANIMAL TO HAVE BEEN SWALLOWED BY A MEMBER OF THE BOA FAMILY WAS A 100-LB COLLARED PECCARY.

..NOT ME. I WEIGH 105 POUNDS.

ANY STORIES ABOUT MUCH LARGER ANIMALS WOULD BE HOGWASH.

SPEAKING OF "HOGWASH," THAT'S PROBABLY WHAT THE BOA DRANK TO FINISH OFF HIS MEAL.

© 1994 United Feature Syndicate, Inc.

ASK SHAGG reprinted by permission of UFS, Inc.

program would be the same as any other humorous illustrator's, but would concentrate on your special talent for caricatures.

For more complete and detailed information on the art and business of caricature, be sure to read *The Complete Book of Caricature* by Bob Staake (North Light Books). This lavishly illustrated, 135-page book features samples, art tips, advice and commentary from the world's leading caricature specialists, including Al Hirschfeld, David Levine, Edward Sorel, Jack Davis, Robert Grossman, Robert Risko, Bill Plympton, Rick Meyerowitz, Sam Viviano and Mort Drucker.

For further study of caricature, treat yourself to a subscription to *The National Forum Gallery of Cartoons*, a weekly review of the nation's best editorial and political cartoon commentary (Associated Features Inc., Box 7099, Fairfax Station, VA 22039).

So far I haven't had any success selling my cartoons. My magazine cartoons are getting rejected and my comic strips always come back with a rejection form. Sometimes I feel like throwing away all my art supplies and giving up!

Peter Guren began his cartooning career as a staff artist for American Greetings and began freelancing full time after signing a contract to create *Ask Shagg* for United Features Syndicate. "American Greetings was the best education I ever had," recalls Guren. "I was surrounded by other cartoonists and writers there. There were many others at American Greetings who were more talented than me, but they weren't as driven. Drive made all the difference for me." Before finding success with *Ask Shagg*, Peter Guren tried ten other comic strip ideas which failed to attract any syndicate attention. Guren's natural curiosity about animals is shared by his readers, who send him more than 1,000 letters every month.

Is there there any way I can keep from feeeling so discouraged**?**

Learn to accept discouragement and frustration as a normal, and even helpful, part of cartooning. *Everyone* gets discouraged and frustrated. If you are feeling that way at times, then you're just like every other cartoonist who ever lifted a pen. These feelings are normal, so try to understand and accept them.

Unless you are unusually stable psychologically, you're going to feel some discouragement and frustration at every stage of your career, no matter how far you progress. Beginners get frustrated when they're learning to draw and write, moderately successful professionals get frustrated when they aren't accomplishing their higher goals, superstars get discouraged and fearful when their comic

strip is dropped by a major newspaper or does poorly in a readership poll. We all care about our work, and it hurts when things don't go the way we want them to. No matter how far you climb up the ladder of success, you will meet discouragement and frustration from time to time at every level. Feeling disappointed when you fail is normal, so don't feel bad about feeling bad.

Your frustration, however, can be a source of great energy and a springboard to accomplishment. Frustration makes you want to jump up and down and scream and pound the walls. If you turn your frustration inward, you will use that energy to beat yourself up psychologically and feel bad. If you channel all of that energy into your work, however, you can make a supercharged leap forward in your career. When you're feeling upset with your progress, go ahead and get angry, but use that anger to strengthen your resolve to do better, to become stronger. Climb up on top of your drawing board and shout "I'll show them!" Then climb back down and show them!

Time and time again, in various books and magazines I've read, famous cartoonists claim that persistence and perseverance are the keys to success. Is it really as simple as that?

As long as you believe in yourself, you should never give up. It's often been reported that Colonel Sanders encountered one thousand rejections before the first backer finally agreed to support his idea for Kentucky Fried Chicken, now generally known as KFC, restaurants. Unfortunately, persistence can work for you and it can work against you. Persistence can keep a good idea alive long enough for it to grow and flourish, but it may also keep you glued to a bad idea that should have been abandoned long ago.

If your work is receiving some favorable response from friends, co-workers or editors and if their comments seem to be sincere, then let that inspire you to push toward the next level of accomplishment. If you manage to get your first cartoon published in your high school, college or local city newspaper, let that one small victory inspire you to climb to the next accomplishment, then the next and the next. Successful careers don't just land in your lap full grown, they're built one accomplishment at a time.

To reach your goals, keep one eye focused on the big dream and one eye focused on the little daily goals and achievements. Sure, it takes practice to see the world this way, but it's a fundamental skill you need to succeed in any career, not just cartooning.

To succeed in cartooning in a big way, you must do something that nobody else is doing. You must create something fresh, exciting or interesting that is different from everything else out there. The world does not need another *Far Side* clone, for example. *The Far Side* became a huge success because it was radically different from *The Family Circus*, *Peanuts*, *Beetle Bailey*, *Ziggy*, and every other comic in the newspapers. There have been numerous *Far Side* imitators over the years and none have succeeded in a big way because they were

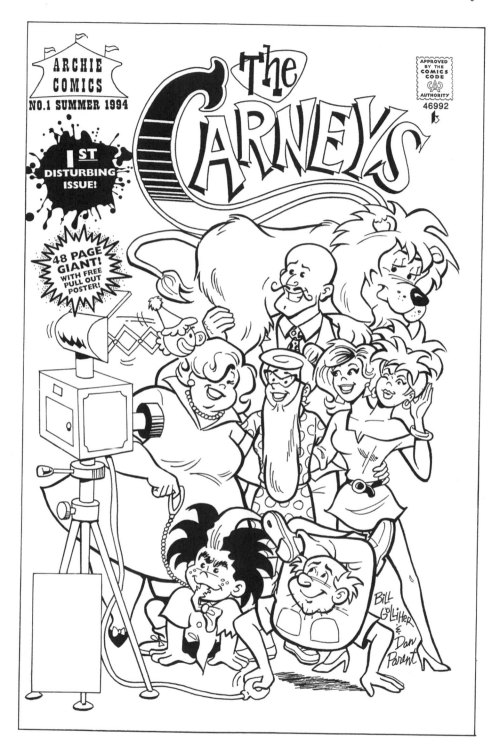

This comic book cover was drawn by Dan Parent. Since most comic book artists are paid on a per-page basis, Parent suggests that anyone seeking employment in the field should learn how to draw well—and learn how to draw fast. A slow artist will probably not be able to turn out enough pages per week to earn a livable income. To find employment as a comic book artist, you must also have the ability to faithfully render well-known characters and styles, such as *Archie, Ren and Stimpy, Ritchie Rich* or *Superman.* A strong portfolio is all you need to get your foot in the door and make your initial contact.

© 1994 Bill Golliner and Dan Parent.

Illustrator Profile:
JARED LEE

Jared Lee is one of the most successful and most highly respected humorous illustrators in the United States. He has created advertising illustration for numerous clients, including Ralston Purina, John Deere, U.S. Postal Service, Sunkist, EXXON, New York Telephone, Kraft Foods and McDonalds. His magazine credits include *Playboy, Esquire, Readers Digest, Woman's Day, Cosmopolitan* and *Saturday Evening Post,* and his work can be found on countless greeting cards from Hallmark and Gibson Greetings. His love for horses has inspired him to create an extensive line of gift products for horse lovers, featured in a full color, twenty-page catalog full of mugs, dolls, shirts, notepads, coloring books and tote bags featuring his humorous horse cartoons and designs.

Children's books now play a major role in Jared Lee's illustration career. According to a survey published in *USA Today,* Jared's book *A Hippopotamus Ate the Teacher* (authored by Mike Thaler) is the number one most popular book among children in early elementary school grades and has sold nearly one million copies since it was first published in 1981. Other successful Lee/Thaler collaborations include *The Bully Brothers* series, *The Teacher from the Black Lagoon* and *The Principal from the Black Lagoon.*

"My first big break in children's books came in 1981 with Avon Books," Jared recalls. "This was *A Hippopotamus Ate the Teacher,* my first project with author Mike Thaler. I had shown my samples to the editor at Avon, she liked my work, we had lunch together and she promised to keep me in mind for any suitable projects for my work. That's how my first big children's

book job came about. I had done some smaller children's book projects before this, but this was the first really big one with an advance and royalties. I found an editor who was willing to take a chance on a new guy and it worked out for everyone. In publishing, you talk to editors first; art directors come into the project later. The author's manuscript goes to the editor, then the editor chooses an illustrator. This is how I first got involved with Mike Thaler in 1981—we never actually met face to face until 1992.

"Children's books require no special talents or skills different from other kinds of humorous illustration projects—it's just a different format. I get the story from the editor, read the story, know how many pages I have to work with, decide how to lay it out with the author's words, then do my first sketches. Once the sketches are approved, I do the finished art. Most of my books are thirty-two pages and a cover, so it's a lot more work than most other projects. I draw fast, maybe faster than a lot of people, but even at my speed, I'll have at least 150 to 200 hours in each book."

Jared Lee believes that art is a God-given talent which must be nurtured with as much education, training and practice as possible. "I was always drawing as a kid. My high school was so small, they didn't even offer art. Later I went to the John Herron Art Institute in Indianapolis for four years. I studied design, sculpture, illustration, advertising, drawing, painting, photography and art history. It was four years of nothing but art. I loved it! I loved the smell of that place, the paints, the oils. I wish I could put that smell in a bottle and sell it! I went to school for one more year after that to get my degree, a B.F.A. in advertising from Butler University. After that

© Jared D. Lee Studio, Inc. 1995.

I went in the army for two years and began to freelance for some greeting card companies at that time. When I got out of the army, I received job offers from Hallmark, American Greetings and Gibson Greetings. I took the job at Gibson Greetings and stayed there for thirteen months before leaving to start my own freelance business in 1970.

"Keep your dream alive," Jared advises. "If you want to be an artist, don't let anyone stop you. Once you've paid your dues and things start happening for you, there are a lot of rewards!"

only pale clones of something original. Likewise, *The Simpsons* became a smash hit on television because it was a bold, original alternative to *The Smurfs* and other ordinary, predictable animated cartoon programs.

Being fresh and original is not enough, though. If you want to be a great cartoonist, you must also be a great entertainer. You must have the ability to communicate ideas that the public will care about, and do it in an amusing and popular way. Your task is not much different than that of a comedian or singer—you are entertaining with your words and pictures instead of your voice.

To help yourself become a great entertainer, spend some time thinking about other great entertainers, everyone from the Marx Brothers to Garth Brooks. What is so special about the great ones? What do you have in common with great entertainers and what can you learn by studying them? What separates the good entertainers from the great ones?

What is the difference between a good cartoonist and a great one?

Taking time to ponder the psychology of humor and entertainment can be a great help to any cartoonist. Whether your goal is to create outrageous Shoebox cards for Hallmark, to land a job creating new animated characters for Hanna-Barbera or to sell gag cartoons to *The New Yorker*, the more you know about being a great entertainer, the better your chances are of becoming successful in your cartooning career.

Finally, you must take action toward all of your goals. This is the only way to turn your daydreams into reality. You've got to sit in the chair and do the work. This book can show you a few new tricks and inspire you, but it's worthless unless you follow through with plenty of good old-fashioned effort. Nobody else can do the work for you. Don't count on being discovered by some slick big city agent who's going to make you a star. Fancy deals don't make great cartooning careers—great cartoonists make great cartooning careers.

So now that you've come to the final page, its time to put down the book, pick up your pencil and get back to work—and play!

Good luck!

Animator Profile:
MARTY JONES

Marty Jones is an art director for *Children's Playmate* magazine, but has a full and active background in animation. For four and a half years, Marty worked for Perennial Pictures, a small animation studio in Indianapolis, where he participated with nine other artists in the creation of commercials and short features for cable TV and home video. "My art skills were pretty raw," he admits. "Despite years of cartooning, I had no formal training in the basics of drawing. What really cemented my hiring was my background in amateur film production. Understanding the process of filmmaking is necessary when working in animation. You need a knowledge of how the passage of time is accounted for on film. An animator has to dissect a scene piece by piece, frame by

frame. In the fragmented process that makes an animated cartoon, understanding the parts is prerequisite to understanding the whole."

Jones began at Perennial Pictures as an animation assistant. Eighteen months later he began working as a full-fledged animator. "An animator needs to understand the dynamics of motion and balance. You're not merely drawing pictures. You're duplicating movement. The way to learn this is to observe the way things move and translate that to the peculiarities of animated filmmaking. Working as an assistant is an excellent way to develop these instincts."

Marty Jones is now publishing a high quality, highly recommended publication called *The Aspiring Cartoonist*. For information, write PO Box 18679, Indianapolis, IN 46218.

Bill Schorr is the award-winning editorial cartoonist for *The Kansas City Star* newspaper. His insightful political cartoons are syndicated by United Features and reprinted in newspapers all over the world. He is also the creator of *The Grizzwells* comic strip, syndicated worldwide by NEA Inc.

Even with a computer modem to assist him in delivering his work to the syndicate editors on time, Schorr is a very busy man with a full schedule. "I try to write all of my strip ideas over the weekend and start drawing on Monday. Tuesday through Friday I work on my editorial cartoons. Then I finish up the strips after my editorial work is done. But I never try to do both at the same time because it tends to divide my concentration and then the work might suffer. Editorial cartoons are easier than strips in some ways because once you define your subject you've got something, a foundation, to build on. The hard part about doing a strip is finding the right subject to write an idea about.

"Editorial cartoons have a certain function," Schorr explains. "They're not just entertainment, they're more of a form of journalism. In college (CAL State University at Long Beach) I studied illustration, political science and journalism. Plus I did four cartoons a week for the college paper. I'd take those four cartoons over to the *L.A. Free Press* once a week and they'd usually publish one of them."

After college Schorr landed a job as editorial cartoonist at *The Kansas City Star*, where they were looking for a new cartoonist with a modern style. "I actually heard about the job from another cartoonist, Dick Wright, who turned down the job," he recalls. When the *Star* was sold in 1978, he found employment with the *Los Angeles Herald Examiner*, upon the recommendation of

cartoonist Paul Conrad. After a disruption in management at the *Herald Examiner*, Schorr found himself back in Kansas City working for the *Star*, who had decided they had enough room on their staff for two cartoonists. Schorr has been working for the *Star* ever since, dividing his time between their newspaper offices and his own home studio.

"To get a job as an editorial cartoonist, you should start with a small paper," Schorr believes. "Then move up the ladder as you gain more experience and build a reputation for yourself. Keep your day job if necessary and do a few editorial cartoons for your local paper for a small fee. Eventually you might be able to land a staff job." According to Schorr, a newspaper staff cartoonist can earn a comfortable middle-class income with a pay scale similar to other newspaper jobs, perhaps quite a bit higher if you have an impressive reputation which your cartoons may lend to the newspaper. Plus there are pay raises, insurance and other benefits of steady employment. If your editorial cartoons are picked up for distribution by a syndicate, your income can increase again.

Throughout his cartooning career, Bill Schorr has maintained a love for comic strips. His first strip *Conrad* (with a medieval cast featuring an enchanted frog) enjoyed a successful launch with Tribune Media Services in 1982, but ultimately failed due to what Schorr believes was a combination of his personal inexperience and lack of creative focus.

His next strip *Phoebe's Place* (whose cast featured an owl, a pussycat and various political figures) was syndicated by the Los Angeles Times Syndicate, and was far more political and outspoken than his first strip and its very sharp flavor prevented it from becoming the main-

GRIZZWELLS® by Bill Schorr

"...IS IT MY IMAGINATION OR DOES IT SEEM LIKE EVERYONE IS TAKING PROZAC?..."

stream success Schorr had hoped for. Despite these setbacks, Bill continued to believe in himself. He knew he was capable of creating work as good as, or even better than, many of the strips that were running in the papers. Today Bill is back on the funny pages with *The Grizzwells*, a long-running and popular strip about a family of bears.

Like most successful cartoonists, Schorr's advice to newcomers focuses on the importance of education. "You can't read enough. The more information you get, the more you have to work with in your cartoons."

Resources and Extra Stuff

Here are the addresses of some books, catalogs and other resources to help you achieve your cartooning success faster.

American Business Lists
5711 South 86th Circle
Omaha, NE 68127
Another good resource for mailing lists

American Showcase
915 Broadway
New York, NY 10010

Artgrafix
15 Tech Circle
Natick, MA 01760
A very well-known mail-order art supply company. A catalog is available

Artist's & Graphic Designer's Market
1507 Dana Avenue
Cincinnati, OH 45207
Guide to various markets such as advertising, art/design studios, publishers, galleries, record companies and greeting cards, gift items and paper products.

The Artist's Magazine
1507 Dana Ave.
Cincinnati, OH 45207
Monthly publication for fine artists, illustrators and cartoonists. Columns, features, tips and markets for cartoonists.

The Aspiring Cartoonist
P.O. Box 18679
Indianapolis, IN 46218
High-quality publication, published three times per year, focusing on the interests of aspiring cartoonists. Features many articles about successful cartoonists.

Cartoonerama
P.O. Box 854
Portland, ME 04104
Highly recommended correspondence course for cartoonists, well suited for all ages.

Cartoonist Profiles
P.O. Box 325
Fairfield, CT 06430
Quarterly magazine for fans and professionals, featuring several interviews per issue.

Color Q
2710 Dryden Road
Dayton, OH 45439
High-quality color postcards, greeting cards and flyers printed from your original color art.

Creative Access
415 West Superior
Chicago, IL 60610
Mailing lists for cartoonists, illustrators and other creative professionals. Provides up-to-date names and addresses for thousands of advertising agencies and publishers.

Creative Black Book
115 5th Avenue
New York, NY 10003

F&W Publications
1507 Dana Avenue
Cincinnati, OH 45207
Publishes North Light, Betterway and Writer's Digest Books, which offer many books of interest to cartoonists and humorous illustrators. Catalogs are available.

Gag Recap
12 Hedden Place
New Providence, NJ 07974
Monthly publication lists all cartoons published in major magazines; most issues also contain market information. Essential reading for anyone doing magazine cartoons.

Gale Directory of Publications and Broadcast Media
Gale Research Inc.
835 Penobscot Bldg.
Detroit, MI 48226
Publishes extensive listing of publication names and addresses.

Graphic Artist Guild Directory of Illustration
Serbin Communications
511 Olive Street
Santa Barbara, CA 93101

Graphic Artists Guild
11 West 20th Street
New York, NY 10011
Professional organization protecting the interests of graphic artists, cartoonists and humorous illustrators.

The International Animated Film Society
725 South Victory Boulevard
Burbank, CA 91502

The International Museum of Cartoon Art and The Cartoon Hall of Fame
200 Plaza Real
Boca Raton, FL 33429

Joe Kubert School of Cartoon and Graphic Art
37 Myrtle Avenue
Dover, NJ 07801
Three-year art school specializing in animation, comic books and other forms of comic and graphic art.

MacWarehouse
P.O. Box 688
1720 Oak Street
Lakewood, NJ 08701
Reliable mail-order catalog for computers, hardware and graphics software.

The National Forum STRIPS
P.O. Box 7099
Fairfax Station, VA 22039
Humor tabloid prints 400 new comic strips by 60 famous cartoonists every week.

Newsletters In Print
Gale Research Inc.
835 Penobscot Bldg.
Detroit, MI 48226
Directory of newsletter names and addresses.

RSVP Directory of Illustration and Design
P.O. Box 050314
Brooklyn, NY 11205

School of Visual Arts
209 East 23rd Street
New York, NY 10010
Renowned professional cartoonists have been teaching here for more than 40 years. A course bulletin is available.

Standard Periodical Directory
Oxbridge Communications Inc.
150 Fifth Avenue
New York, NY 10011
Another directory of publication names and addresses. A good resource if you're pioneering new cartoon markets.

Witty World
P.O. Box 1458
North Wales, PA 19454
Quarterly cartoon magazine with an international scope.

Writer's Market
1507 Dana Avenue
Cincinnati, OH 45207
Hundreds of listings of magazine and book publishers including addresses, phone numbers and guidelines.

Index